NINA SIMONE'S GUM

'A strange and shimmering book, alive with the deepest questions of what makes us who we are and why we make the life-stuff we call art.' Maria Popova

'A beautiful, haunting quasi-memoir.' *Vanity Fair*

'This is such a beautiful f*@king book.' Flea

'In praise of meaning-rich relics and magical things. A totally heartwarming project.' Max Porter

'What the gum symbolises and the meaning behind what great performers and artists give to people – the transcendence of music in our lives – is what this wonderful book is all about.' *Stylist*

'A unique study of a fan's devotion, of transcendence and of the artistic vocation – it's got depth and great warmth. It's a beautiful piece of work.' Kevin Barry

'A moving, inspirational insight into a beautiful mind.' Jim Jarmusch

'A glorious piece of object fetishism . . . Marvel as Ellis's collection of eccentric personal mementos morphs into a celebration of the intangible wonder of music.' *Uncut*

T0017885

faber

NINA SIMONE'S GUM

A MEMOIR OF THINGS LOST AND FOUND

WARREN ELLIS

First published in 2021
by Faber & Faber Limited
Bloomsbury House
74–77 Great Russell Street
London WC1B 3DA
This paperback edition first published in 2022

Designed and typeset by Stuart Bertolotti-Bailey
Printed in India by Multivista Global Pvt.Ltd

A CIP record for this book
is available from the British Library

ISBN 978–0–571–36563–0

10 9 8 7 6 5 4 3 2 1

For Our Teachers

'Would you come to me
If I was half drowning
An arm above the last wave.'

Lou Reed, 'Junior Dad'

Introduction

*It was 1 July 1999 and I was hanging around back-
stage at the Meltdown Festival in London. I was the director
of the festival that year. It was the Nina Simone evening.
Germaine Greer had just come off stage after reading Sappho
in the original Greek to a genuinely perplexed audience.
Nina Simone was locked in her room and was not seeing
anyone. People were running around screaming stuff at me.
It was a typical Meltdown evening of genius and barely
contained chaos.*

*Nina Simone was a god to me and to my friends.
The great Nina Simone. The legendary Nina Simone.
The troublemaker and risk taker who taught us everything we
needed to know about the nature of artistic disobedience.
She was the real deal, the baddest of them all, and someone
was tapping me on the shoulder and telling me that Nina
Simone wanted to see me in her dressing-room.*

*Nina sat in the middle of the dressing-room dressed
in a white billowing gown. She wore bizarre metallic gold
Cleopatra eye make-up. Pressed against the wall of the room
sat several attractive, worried men. She sat, imperious and
belligerent, in a wheelchair, drinking champagne. She looked
at me with open disdain.*

'I want you to introduce me!' she roared.

'Yes,' I said.

'I am Doctor *Nina Simone!'*

'OK,' I said.

*I knew that I stood within the presence of true
greatness, and was happy that, for a small second, I existed
within her orbit and that my life would be marked by this
moment. I loved her.*

*I did what she asked and introduced her to the crowd,
and then stood in the wings and watched her negotiate the
stairs to the stage – it was clear that Nina Simone was not well.
I watched as she walked slowly, painfully, to the front of*

1

the stage. She stood ferocious and majestic before her audience, arms at her sides and fists clenched, staring down the crowd. In the audience, five rows back, I could see Warren's face, awestruck and glowing as if from a dream.

Nina Simone sat down at the Steinway. She took a piece of chewing gum from her mouth and stuck it on the piano. She raised her arms above her head and, into the stunned silence, began what was to be the greatest show of my life – of our lives – savage and transcendent, and the last performance of Nina's in London.

The show ended in mutual rapture and Nina Simone left the stage a different person – restored, awakened, transfigured – and we too were changed and would never be the same. Not ever. As I turned to leave, Warren was crawling up onto the stage, looking possessed and heading for the Steinway.

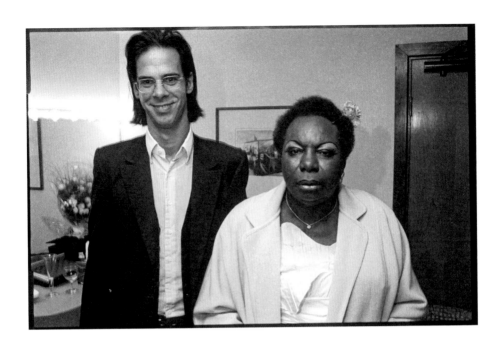

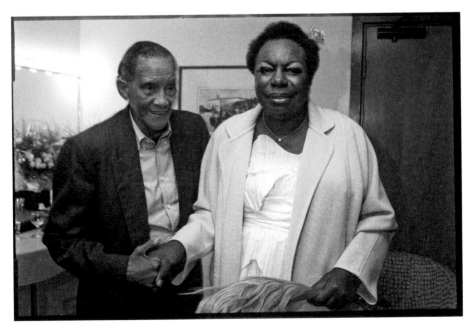

Twenty-one years have passed. The piece of chewing gum belonging to Nina Simone, which Warren retrieved from the piano at the Meltdown Festival and rolled up in her hand towel, is being placed on a marble pedestal in a velvet-lined, temperature-controlled viewing box. We are in the Hallway of Gratitude, part of the Stranger Than Kindness exhibition at the Royal Danish Library. As the chief conservator places the little piece of grey gum on the plinth like a hallowed relic, we are all silent, awed.

Warren has kindly released the gum into the world. He has turned this memento, snatched from his idol's piano in a moment of rapture, into a genuine religious artefact. It will sit there on its plinth in Copenhagen as thousands of visitors stand before it in wonder. They will marvel at the significance of this most ordinary and disposable of things – this humble chewing gum – how it could transform, through an infusion of love and attention, into an object of devotion, consecrated by Warren's unrestrained worship, not just of the great Nina Simone, but of the transcendent power of music itself.

The chief conservator of the Royal Danish Library adjusts a small yellow light that shines directly onto the piece of gum, and we all stand back a little, and with held breath, watch it glow.

Nick Cave
1 July 2020

1.

When I was maybe 4 or 5, my older brother Steven, who was 6 or 7, woke me up with his giggling. He was sitting on his bed in front of the window, bathed in light, peering through the crack between the roller blind and the frame. I could only see his outline, backlit by the light, like the shadow scissor-cut out of a facial profile. There was a glowing white light illuminating the window facing the backyard. Light bursting from the space between the roller blind and the window frame.

'What is it?' I asked.

'Come and look.'

I went and sat next to him on his bed. He pulled the roller blind away from the frame. The backyard was full of clowns. The sky was full of light. Like a giant flashbulb that flashed for ever. On the lawn was an egg-shaped caravan. It had been converted into a food cart, the window flap held up to make an awning. Inside were clowns making hamburgers. They had a griddle fashioned from corrugated iron to cook the mud patties and would place them between two large gum leaves then pass them to the clowns gathered under the awning. There were clowns everywhere. Smiling and contorting, doing somersaults. Hiding behind trees. Taking aim. Throwing the hamburgers at each other, playing in the large eucalyptus trees near the bedroom window and the crimson bottlebrushes that grew over the wooden back fence. Standing on the top branches of the yellow wattle trees. Scaling trees like cats, hanging upside down with their legs curled around the branches, their clothes covered in mud stains and eucalyptus leaves. They made no noise. Our laughing woke our father in the other bedroom. He asked if everything was OK.

'There's clowns in the backyard!' I yelled.

My father replied half asleep from his bedroom, 'They will be gone in the morning. If they aren't, your mother will

scare them away when she hangs the washing out on the clothes line.'

After some time, my brother and I got tired and fell asleep. We woke in the morning and looked out the window. They were gone. The caravan had vanished. The backyard never looked the same after that.

Every night before bed our father would stand in the doorway of our bedroom with his head bowed, bathed in the amber hallway light, and recite a prayer.

> *Our Father,*
> *Who art in heaven,*
> *Hallowed be thy name;*
> *Thy kingdom come,*
> *Thy will be done,*
> *On earth as it is in Heaven.*
> *Give us this day our daily bread;*
> *And forgive us our trespasses,*
> *As we forgive those who trespass against us;*
> *Lead us not into temptation,*
> *But deliver us from evil.*
> *For thine is the kingdom,*
> *The power and the glory,*
> *For ever and ever.*
> *God Bless Mummy, Daddy, Steven, Warren and Murray,*
> *All the little girls and boys,*
> *All the doctors, nuns, nurses and teachers,*
> *Please love us all.*
> *And guard us and guide us,*
> *For ever and ever,*
> *Amen.*

I'd lie in bed wondering who the mysterious Gartis and Gytus were. I believed the prayer was written by my father. When I started going to church I wondered why the priest didn't recite all of the prayer my father had given to him.

After prayer I waited for dusk. Lying in bed the twilight would come to life. These clear shapes gently moving; comforting spirits touching my face, transparent amber barley sugar cascading silently. I could see the dark. I was never afraid. One day these spirits went away. I've looked for them ever since. Waiting for them to return.

2.

August 2019

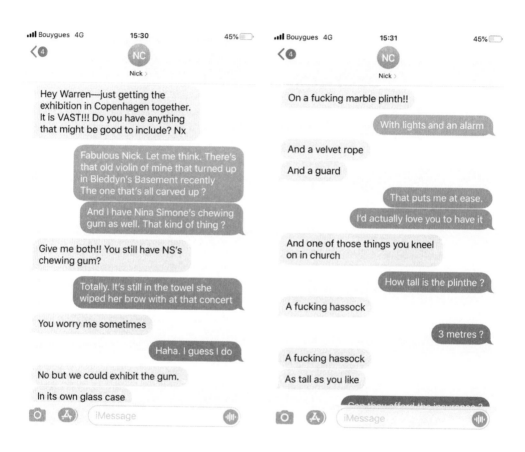

Left screen:

NC
Nick

Hey Warren—just getting the exhibition in Copenhagen together. It is VAST!!! Do you have anything that might be good to include? Nx

Fabulous Nick. Let me think. There's that old violin of mine that turned up in Bleddyn's Basement recently The one that's all carved up ?

And I have Nina Simone's chewing gum as well. That kind of thing ?

Give me both!! You still have NS's chewing gum?

Totally. It's still in the towel she wiped her brow with at that concert

You worry me sometimes

Haha. I guess I do

No but we could exhibit the gum.

In its own glass case

iMessage

Right screen:

NC
Nick

On a fucking marble plinth!!

With lights and an alarm

And a velvet rope

And a guard

That puts me at ease.

I'd actually love you to have it

And one of those things you kneel on in church

How tall is the plinthe ?

A fucking hassock

3 metres ?

A fucking hassock

As tall as you like

iMessage

8

Can they afford the insurance ?

There is Hallway of Gratitude. It could go there in a yellow velvet lined box with a little marble plinth. It would be beautiful. What color is the gum?

To be honest I've only looked at it a few times. The last time was when we spoke about it in 20k days. It just sits in my studio and knowing it's there is enough. Let me see

If you want it I'd love people to see it. What greater piece of gum is there?

It's heartbreaking

Ohh

You're heartbreaking!!!

I've got to go. I'll get Christina to sort it all out. A beautiful idea. A holy relic.

Yes. It feels like something.

Pure religion

I'll bring it over when we continue working on those new ideas

Ok

That spinning song idea is so beautiful

In 1975 I began taking lessons on the violin. The violin
in the text conversation with Nick is the first violin I owned.
The violin I played from 1975 through to 1996; through
primary school, secondary school, university and the first half
of the nineties when I started playing in bands. There's
a photo my dad took of me in the backyard in 1977 playing
this violin, wearing a green t-shirt and jeans, back-dropped
by a typical Australian wooden fence and a blue sky.
Miss Nevett's tree is in the background. I remember he told
me to angle my first ever wristwatch to catch the sunlight.
The watch had a thick leather embossed strap and was a
recent 12th birthday present. I was more proud of the watch
than the violin.

I had started playing the accordion in 1974. It was my
first instrument. I used to hang around a rubbish dump in
Alfredton, Ballarat, with my two brothers, Steven and Murray.
It was our hangout, a place to dream and practise smoke
rings with a packet of Winfield Blue and Alpine Menthol
under a weeping willow outside the perimeters. It was built
on the site of a disused quarry that was filled with stagnant
water, and the craziest seagulls and ibises kept watch.
The surrounds of the quarry were piled high with mullock
and waste from the mine. The path to the tip was legendary
for its swooping magpies. Many a gauntlet had been run trying
to access it. Legend said the lake was bottomless, inhabited
by creatures. It was there I decided that I wanted to repair
bicycles when I grew up.

I found a discarded Hohner piano accordion one day,
black with 120 bass buttons. I stepped on it in the rubbish and
heard it wheeze. It was massive and weighed a ton; the smell
of it made my intestines move, like when you enter a thrift
store. My older brother found a motor-mower engine. He grew
up to be a car mechanic. My mum made a draw-string bag
from orange and purple material for a case, and I lumped the
accordion to school over my shoulder, Santa-style. My teacher,
Geoff McClean, played accordion and gave me lessons. Every
day he would start class with a few tunes he played on the

accordion and we would have to guess what the tunes were. I decided to learn the violin a year later, in 1975, when a visiting violin teacher, John Hughes, asked if anyone wanted to learn the instrument and I noticed all the girls raised their hands, so I raised mine.

My father knew this guy, Eric Wilson, who sold second-hand instruments, and he was certain he would have a violin. Dad played guitar and wrote country and western tunes and he had taught briefly with Eric Wilson at Wood's Music in Sturt Street. We paid him a visit. He had a room in his home full of every type of instrument under the sun: banjos, guitars, drums, saxophones, dulcimers, weird trumpets, brass, woodwind and some violins. I stood at the door and looked with wonder at this room as he rummaged through it. He would pick up an autoharp and give it a strum, blow a note into a sousaphone, picking his way carefully and passing instruments out to make room. All these silent instruments. The potential. He returned from the room with two fists full of violins, clasping two in each hand by the neck. I could kind of play 'Twinkle, Twinkle, Little Star'. I chose this particular violin from the four, and my parents bought it for me for twenty Australian dollars. It became known in the family home as 'the old German one'. It felt enormous on my shoulder and smelt like Arnott's Milk Arrowroot biscuits. When I arrived at the class with my violin there was me and another guy, Craig Menzies, and no girls. He had one pointed ear that protruded from his Cobain-blond dead straight hair and he said he was a Martian. He was in the grade above me. He'd build flying saucers from a wheelbarrow and a kitchen chair in his parents' garage and tie them to the tow bar of the family car with a long piece of rope. When his mum drove away he would put on a large motorcycle helmet, sit on the kitchen chair attached to the wheelbarrow and yell, 'This is it. I'm taking off. I'm going home.' My brother Steven and I would stand in the doorway of the garage, announcing the countdown, watching him in awe under the lunar fluorescent lighting. So I started the

11

violin with Craig Menzies. He lasted a week. That left only me. I was 9 years old.

The same year I was doing a paper round on my bike. I delivered newspapers and overdue library cards until I was 15. Six years, my personal best at holding down a regular job. One day, for some reason, I picked up this lead weight I saw lying on the road. It's a particular kind of weight that is hammered on car tyre rims to balance them so they turn evenly. They vary in size dependent on the weight needed and can be anything from a centimetre to 10 centimetres in length. I put it in my pocket and kept it. I associated it with good luck. From that day on, anytime I would see a tyre weight I'd have to stop, pick it up, pocket it, or throw it in my school bag. If I found one for a truck, it was a good day. They were 20 centimetres in length. Big luck!

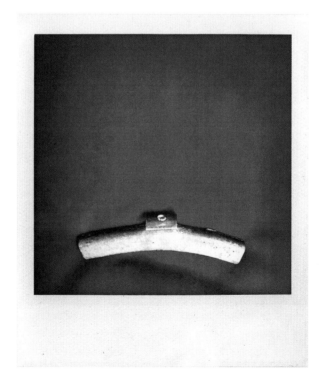

I wouldn't pick up broken weights because I sensed the luck was gone. I would transfer unbroken weights to a cardboard box that had transported food from Cincotta's fruit and vegetable store, 201–209 Mair Street, Ballarat. I kept it under my bed. A treasure chest. A fist of bananas printed Warhol-like on the side. I remember R and H Foodland that was located in Pleasant Street around the corner from the fruit shop near Crawford's Pharmacy. It had the name of the store in large font on the brick façade above the entrance. There was a large Winnie the Pooh-style beehive full of honey with a light inside that made the honey glow magically through a transparent section on the side. It was sitting on a table amongst the fruit and vegetables. From the entrance you could see it glowing. I would stand in the doorway and look at it before entering. There was a black handle that you would place a jar under and lift and fill with honey. I would stand beneath it and stare up at that beehive and imagine being inside it, bathed in the amber light. Opposite Crawford's Pharmacy was St Peter's Church where my father's prayers were recited the first Sunday of every month.

I eventually filled the box under my bed with:

- lead tyre weights
- *Phantom* comics
- treasures from the local rubbish dump
- flint cigarette lighters which needed fluid
- World War II bullet cartridges that had been formed into airplanes and letter-openers
- broken peacock feathers
- yoyos
- overwound watches
- a thin leaflet of unexplained mysteries with images of the Loch Ness monster, Cottingley fairies and Yeti
- pocketknives
- stickers
- a bike-tyre puncture repair kit

- a small quarter-full stamp book with embossed butterflies on the cover
- cassettes
- *Mad* comics
- two tortoise-shell-framed magnifying glasses. A small and a large
- a black wooden elephant with a broken trunk

My dad had a box of his own secrets in a high cupboard in the hallway. A box of lyrics he had written for songs he wrote on the guitar. One was titled 'Mis'ry Is My Middle Name'. There were also multiples of a photo of him with his guitar which he planned to autograph for fans when he finally made a career.

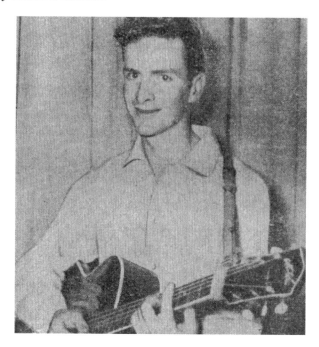

Pieces of paper where he practised his signature. Lead stamps with his name, Johnny Ellis, to print on the photos. Next to the box was a pile of 78 rpm vinyl. Mostly Hank

Williams, Luke the Drifter, and the odd Chad Morgan.
Some Little Richard, and the Everly Brothers. He would sit
around the house playing these songs he'd written. He'd open
a book of poems and make a tune up on the guitar and sing
them. He recorded one single before he started a family,
a self-financed 45 rpm recording of 'Mis'ry', and a 78 rpm of
'It's No Wonder' backed with a live version of 'The River Looks
Lonely Tonight' at the Queen Elizabeth Geriatric Centre.
Then one day I guess he packed his songs in that box.

 I rode a bike to school. I rode a bike all the time.
It was everything. Freedom. 'Be home before it's dark,' was
all my mother would say as I rode down the gravel driveway.
My school bag was weighed down with these weights, and
they made holes in the bottom of it. They would fall out of the
holes, much to my embarrassment, and be greeted by quizzical
stares. I guess my box was thrown out at some point in time
after I left the family home in the early eighties.

 It's something I do to this day. Subconsciously I still
bend down and pick them up. Although there are fewer on
the streets, it seems. Maybe there's a new process to balance
rims, or tyre rims are made differently. Or maybe they attach
better. I don't know. If you look in my current travel bag
you'd find one or two in there. There are little stashes of them
in drawers and plastic bags. In a side pocket or swimming in
the bottom with the other stuff. It can ruin my day walking
past one and not bending down. If I am on tour playing
concerts, or in the studio working on a project, there is no
way I will not pick them up if I see one on the ground.

 I auditioned for a music scholarship in 1976 to study
music at a local private school, Ballarat Grammar. I played
an old bluegrass tune, 'Orange Blossom Special', a tune
I used to watch Johnny Cash close his TV show with,
a harmonica version, every Sunday evening. My father would
religiously record the show on his reel-to-reel tape recorder
with a microphone pointed at the distorting television speaker.
He demanded a reverential silence from us. He seemingly
knew how to play every Johnny Cash and Hank Williams song.

15

He bought me a book with the piece 'Orange Blossom Special' transcribed for fiddle. When I played this piece for the scholarship audition this impossibly tall guy, Alan Woodend, came over and put his hand on my shoulder. He smelt of tobacco and his fingers were long and bent, his knuckles gnarly and hairy.

'Do you have any idea of the technique involved in playing that piece?'

'I don't,' I replied.

'How did you hear that piece?'

'On the television, watching Johnny Cash.'

He smiled. The next day he called my parents to offer me the scholarship.

I was obliged to play a second instrument, so my mum suggested the flute because it fit in my school bag on my bike. So I started the flute as well. In all truth I don't recall practising very much, ever. I mostly listened to music. I never particularly liked the violin. It seemed to have attached itself to me. The flute wasn't even a detail. In 1983 I had to choose between university and a job I had been offered at McDonald's as a manager. My flute teacher Keith Wilson took me aside and said, 'Don't be a bloody idiot, Warren. You have something with music. Go to university. Let me arrange an audition in Melbourne for you.' I chose university, and the violin and flute came with me.

3.

I went to London in January 1988 to meet a girl I'd fallen in love with in Melbourne. Her name was Zenep and it just didn't happen. She had sent me a cassette by Arleta Αρλέτα, a Greek singer from the Greek New Wave of the sixties, while she was in Athens and I carried it with me. I played it on a Dictaphone cassette player with an internal speaker.

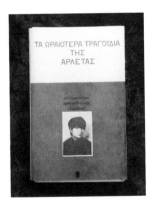

I found myself in winter, in London, 3 January 1988, with that violin which I didn't even particularly like. My head full of young sorrow and a heart like a Lamington cake soaked too long in the chocolate syrup. No coconut. I stayed in Europe for ten months and I ended up hitchhiking across the continent with my violin, busking in the streets, or wherever, drenched in a song, 'Mia Fora Thymamai', sung by Arleta. Somehow that violin came to my rescue, became my friend and the therapist I needed. It took me some time to embrace this instrument on which I can play a range of an octave and a half and have an 'unusual' relationship to time and pitch. Or maybe for it to embrace me.

I was just so used to carrying it, which was why I had taken it with me in the first place. I was aimless and agitated in a winter I couldn't even imagine. I would stand

in the streets, just hanging out with my violin, messing around, busking, passing time. I didn't know what to do, so I played. When I played the chatter and noise stopped. I knew the world I was in. Sound and emotion. The rest just disappeared. I'd close my eyes and see light with the sound. The present obliterated. My concerns forgotten.

I was living in Brighton. I decided to take a train to Inverness, Scotland, because there was this railway deal to go as far as you could in the UK for only nineteen pounds. I took a ticket as far as I could. I spent a week staying in a halfway house for itinerant men. I was playing my violin in the street in the drizzling rain. One eye on the Loch looking for that head. This guy appeared with an overcoat, hat and beard, looked at my empty case, took me aside and said, 'Hey, if ye wannae make some money, watch this. Give me yer fiddle!' I handed him my violin and he started playing folk tunes. People immediately started giving him money. He told me, 'Yer going to go nowhere playin' the shite yer playing.' At the time I didn't believe in melody or timing or pitch, so I was just improvising the most atonal dissonant stuff. A tsunami of pissed-off bees. He left. I started playing again, and I heard a thud in my open violin case. I opened my eyes. He had bought me a book and thrown it in my case: *Scottish and Irish Folk Tunes, Book 4.* He introduced himself as Charlie. I offered to buy him a drink, he accepted and took me to a bar and showed me how to play a few tunes. The next day, playing these tunes, I noticed there was an exchange that went on between me and the people listening on the street. They would visibly change, their mood would lighten, their gait would quicken. They would smile and hum along. They'd give me money. It was one of the first real, communal experiences that I'd had playing music. Until then I was always the one taking from it, listening to records or watching bands. Music from an early age outlined the world for me, framed it, helped me stand in a world I found hard to define and navigate. Words moved me but I could never find my own. But music, I could hang things off it, form wordless

emotions. Swooping strings could take my breath away.
A vibrating coat hanger.

Charlie told me he lived on a whisky distillery in Banffshire, so I went with him and lived in a worker's cottage, and just sat and learned how to play tunes.

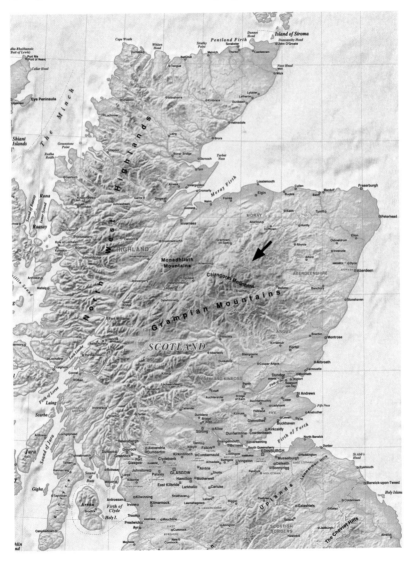

He had an Old Testament red beard and his trousers were held up with a piece of string. He showed me how to make a curry with a tin of sardines, and to add a pinch of salt to porridge when cooking it. I'd sit in the kitchen with a metal potato peeler, carving things in my violin. A cracked heart like a cut-in-half pomegranate with an arrow through it on the front. A crude Jesus on the cross on the back. We'd go busk in the streets and bars with a Polish singer named Pedro, with a beautiful tenor voice. Eventually I moved on to Edinburgh alone for about a month. It was March 1988. I'd sit on the steps of the Princes Street station and play my violin so I could pay for my board at a local hostel. I was in a bar one night, the Green Tree in Cowgate, and a guy walked in with a case. The place went silent. 'That's Hamish McTavish, best piper around here,' the barman whispered to me. Some drinks appeared. 'Play us a tune?!?' Slowly and with ritual, he placed the case on the bar, opened it and assembled his pipes, took a drink, then played the most beautiful lament I'd ever heard. What struck me most was the reverential silence which followed.

I hitched to Glasgow. I took the ferry from Holyhead to Dublin. I was in O'Donoghue's in Dublin sitting in on a session. O'Donoghue's is located just off Dublin's famous St Stephen's Green near the Shelbourne Hotel, on Merrion Row. A guy nodded at me to take the lead. I started playing 'The Rakes of Kildare' and then I went into another tune, 'The Muckin' O' Geordie's Byre'. The banjo player stopped and cursed me. Raised his instrument in my direction like a baseball bat. I'd gone into the wrong tune. A ruddy faced fiddler next to me with red mutton-chop sideburns and bald as a brick screamed, 'He's just a kid, keep playing!' And they did. I went outside, sat in a stairwell and threw up black.

I hitched across the continent to Hungary and I met these people from East Germany in a camping ground outside Budapest who were playing medieval music. It was the days when Eastern Europeans could only take holidays in Eastern Europe. One of them, he seemed to be the leader, had a pet

crow that sat on his shoulder and ate food from the corner of his mouth. He made his own clothes from purple and green velour and had a haircut like Napoleon. His nose and lips were Pasolini-shaped. People sat at his bare feet while he played the recorder. I jammed along with them. He was the most exotic creature I'd ever seen. He gave me a *furulya*, a Hungarian flute he made from a reed he found on the banks of the Duna river. I skronked away on it like Ornette Coleman. I sat on it accidently, catching a bus to Vienna.

I carried the cassette of Arleta everywhere with me on that journey. The album was called Τα Ωραιότερα Τραγούδια Της Αρλέτας. I loved the whole album but there was that one song called 'Mia Fora Thymamai', which stopped time. I didn't know what it was about, or anything about Arleta, but I thought it was the most beautiful song I'd ever heard, and it comforted me for 2 minutes, 31 seconds. I would look at the cover often wondering who Arleta was. There was a black and white photo of her with a wonderful haircut, looking straight at the camera wearing a black tunic.

I lost the cassette at some point so I worked out how to play the melody of this song and it became something I'd play daily in the streets, or wherever. I played an extended version that could last as long as I desired. All I had left was the cover and cracked casing. Then in the early nineties, when Dirty Three started up, I played the melody to Mick Turner and

Jim White and we covered that song in our first rehearsal in my kitchen the day of the first concert. We called it 'The Greek Song'. It became part of our set. Along with 'Indian Love Song', 'Everything's Fucked', 'Kim's Dirt' and 'Odd Couple'. In 1991 I discovered that the translation of the title was 'I remember a time when once you used to love me'. I would just sit there while on tour with Dirty Three, in various states of whatever, carving my violin up with a pocketknife or a corkscrew, and stick water-soaked decals all over it.

Things I carved and stuck:

- an anchor
- a skull and crossbones with Xs for eyes
- a decal scorpion from San Francisco
- some Xs to mark 'clean days'
- a decal of a headless woman from a garage sale in San Francisco
- a decal anchor from San Francisco
- some scrolls that were meant to resemble my grandfather's tattoo on his forearm. He had a scroll with his first wife's name tattooed in there, then had blacked it out with Indian ink and a drawing compass
- Dirty Three carved twice
- some names to remember

As my violin became more beaten and tired it reminded me of Ian Rilen's bass guitar from Sydney band X. I always marvelled at his bass, watching them live in the eighties. The back had a black ring made by a gas burner when his girlfriend tried to set it alight by placing it on the lit stove top. Every note he played seemed etched into it. A chopping block with some strings nailed across it.

I had been custodian of this violin for twenty years, into the nineties with Dirty Three and the Bad Seeds, alcohol and drug stupors, had swung it around my head more times than I remember and avoided breaking it, mostly, managing

to tape it together when I did break it with black gaff tape or bandaids. The wood kept ungluing from my sweat. Eventually a drunk bus driver sat on it in Austria somewhere. Billy was his name. He was pissing on the bus tyre one day and I'd noticed it was a regular occurrence. When I asked why, he replied, "Cos I fucking hate that bus.' I heard he disappeared a few years later. Kidnapped the bus and drove to Eastern Europe. Never heard from again.

I woke up on the tour bus and Billy had passed out in front of a Steven Seagal movie. He was leaning against the violin case comatose. I pulled it out from behind his back and opened it to find the violin had been ruined. Four deep cracks through the belly and the top of the fiddle and the neck had broken away from the body. I needed to play a concert that night so Jim White and I went to the main train station in Vienna and bought another violin at a street market and I played it that evening and through to the end of the tour. I arrived in London when the tour ended to work on *The Boatman's Call* and discovered this violin from the train-station market was less than ideal. Nick Cave gave me eighty pounds to buy another one in a music shop near Sarm West Studios.

After the recording session I took my broken violin to be photographed by Bleddyn Butcher for a promo poster for an album Dirty Three had just completed recording. It was titled *Horse Stories*. I left the violin to be photographed, then went back out on tour. I had met Bleddyn in London through David McComb. Dave had been the singer in The Triffids, from Western Australia. I had been on tour with Dave in Europe in 1994, playing that violin in Dave's band The Red Ponies. Bleddyn was one of Dave's best friends. I forgot all about the violin as I had no use for it broken and couldn't carry it. I just assumed it ended up in a skip or as firewood after the session. It must have been mid-'96.

4 .

5 May 2019

Dear Bleddyn

I've been approached by a publisher, 11 Publishing, about a book of photos of my instruments over the years. It's just an idea for the moment but I would like to see what I actually have laying around.

I remembered this photo you took of this broken violin of mine, poster attached. Maybe you have the photos of this somewhere that I could include?

You don't remember where it might be? I haven't seen it since that photoshoot in '96.

Most of my stuff from back then is gone. In the bin. I also wondered if you had any other busted violins in your pantry?

Be good to see you someplace.

Love

Warren

Dear Warren

Photos of violin have been preserved. I know exactly where they are (in trunk, in study, in Earlwood) – I'd very probably have to re-scan film when I get back to Sydney.

Violin itself has also been retained. I'm not sure exactly where it is – my memory tells me it's in the darkroom at Jubilee Street. Memory can of course be mistaken but instrument hasn't been discarded. I'll have a look when I go round there to talk to tenants (I'm less than a mile away now, in spare room at Terry Edwards' place). If I find, shall I take back to Sydney to return to you? You will be out for the D3 show at the Opera House!

Bleddyn

Dear Warren

I'll have a serious look. I'm pretty sure it's around as I know that I haven't thrown it away (Jude lobbies me to discard well-loved shirts and so forth – I give in, occasionally).

Another reason for my certainty is the fact that I've seen it repeatedly over the ensuing twenty – ? – years. Will let you know once I've rifled through the darkroom (also contains Spook's collection of early-Grime records and plastic Star Wars figures).

There is another possibility, nagging away: I have a very large steamer trunk (in Sydney) which contains various props and masks (including the fabric I bought as a 'backdrop' for violin). Violin might be there as well.

And then a follow-up from Bleddyn the next day:

Found two, in fact, dear Waz, skulking in basement at Jubilee Street. Will send photo tomorrow when – touch wood – the weather's a little brighter and my laptop's back from the doctor's.

BB

In a basement at Jubilee Street. What were the odds of that? It also transpired he had just landed in London the day I sent the first email after a decade living in Sydney, Australia. He fired back an email a couple of days later with these snaps of the violin I hadn't seen for two decades. It had transformed silently in his basement into something more beautiful in the twenty years since I'd seen it. Initially I was more moved by the fact he had cared enough to preserve it.

I must have left the violin at Bleddyn's house after the photoshoot because I literally didn't have anywhere to put it. Instruments are strange attachments, like an

appendage. You take care of them no matter what. You get
used to them being an extra limb. Removing them from
the van each night on tour. Knowing instinctively when you'd
left them behind, running back to wherever you left them.
Perspiring all the way. So for me to leave it behind meant
I had let it go. It was at a point of time when I was constantly
touring eleven months of the year. I didn't have a place to
live. If I did it wasn't for long. I had nothing that was even
abandoned in a corner somewhere – I didn't have a corner or
storage space. I didn't really have anything beyond a suitcase
and a briefcase and this violin. The few things I had I took
care of until they were of no use or broken. I played everything
until it couldn't be repaired or contained with gaff tape.

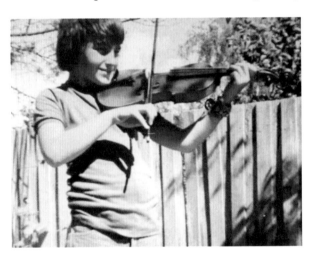

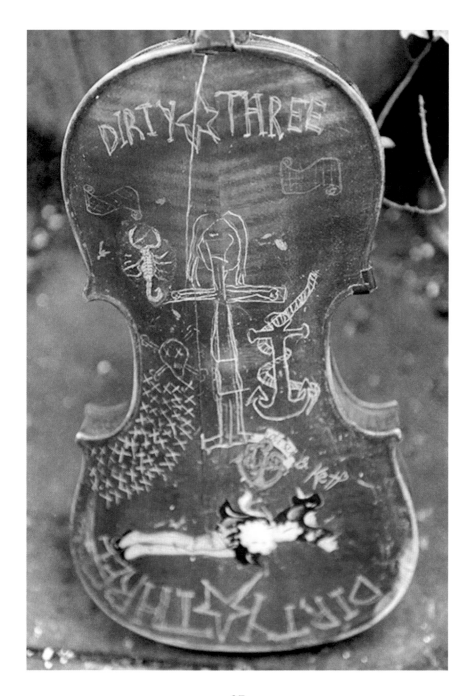

5.

10 September 2013. A kitchen in Bishopstone, England. Shooting the Nick Cave documentary *20,000 Days on Earth*.

Nick: 'Do you remember the Nina Simone gig?'
Warren: 'Yeah.'
Nick: 'Fuck, that was good, wasn't it?'
Warren: 'Yeah, it was up there like ... I've seen a bunch of gigs. That's one that was, like, one of the greatest gigs I've ever seen.'
Nick: 'Do you remember, before she started playing she took the chewing gum out of her mouth?'
Warren: 'Mmhm.'
Nick: 'Like, just sorta sat there, took the chewing gum out of her mouth and just stuck it under the piano.'
Warren: 'On the piano, yeah.'
Nick: 'And just, slam! Hammered into her set!'
Warren: 'I have that chewing gum ... yeah, I have that in my —'
Nick: 'Wait, you took that?'
Warren: 'I took it, yeah. I went up and took it from the stage after the —'
Nick: 'Wait, did you really?'
Warren: 'Yeah. I have it in a towel she wiped her forehead with.'
Nick: 'Oh, fuck. I'm really jealous.'

It was the first time I spoke about the gum publicly, and, strangely, it felt like it was made real by that moment. I had felt this often before in the studio working on music, ideas coming alive, finding meaning and a life outside of the creators. Watching these ideas reach people and find a new life, and losing some control over them once they were out in public. When the documentary was released, people were asking questions. Questions like:

28

'Do you really live in that house perched on a cliff?'
'How do you make eel pasta?'
'Is it true you took her gum?'
'Do you have it still?'
'What colour is it?'
'How big?'
'It's a joke, isn't it, that you took her gum and kept it?'
'What flavour is it?'
'Ever chewed it?'

The gum was real; the rest was, to some people's
disappointment, celluloid real. I hadn't even cooked the meal
of eel and never spent a night in the house. I arrived on the
shoot rather nervous about how I would cook and talk.
Iain Forsyth, one of the directors, sensed my anxiety, and I
explained why. He took me aside and said, 'It's a film, Warren.
You don't actually have to cook the meal' and pointed to
someone preparing the dish in a makeshift kitchen. Something
shifted when others became aware of the gum's existence.
I thought about how many tiny secrets there must be out there
in the universe waiting to be revealed. How many people have
secret places with abandoned dreams, full of wonder.
 I went to the drawer in my attic and took out the
Tower Records bag and removed the towel. I opened it.
The gum was in there. It looked as I remembered, the sacred
heart, a Buddha. That cute rabbit in the moon bashing rice to
make *omochi* お餅 with a wooden hammer that the Japanese
see when the moon is full. Africa. The Welcome Nugget.
Sometimes I saw Christ on a cross, his knees bent to the side.
Her tooth print was still visible. I was both surprised and
relieved to see it was there. I had often turned my imagination
towards its direction, seeking counsel. Alone in my reveries.
Imagining it beating in the towel. Fountaining blood.
 I hadn't opened the towel that contained her gum since
2013. There were two periods when I didn't look at it at all.
I had taken the gum at her London Festival Hall concert in
1999. Between 1999 and 2004 I opened it periodically.

I didn't open the bag from 2005 to 2013. Then from 2013 to 2019 I didn't open it again. I didn't want to disturb it. When Nick asked about it, in 2019 to display in his exhibition, I had to check it was indeed still there. The last person to touch it was Nina Simone, her saliva and fingerprints unsullied. The idea that it was still in her towel was something I had drawn strength from. Like the last breath of Thomas Edison contained in a sealed test tube, kept in the Henry Ford Museum in Michigan. As Edison lay dying, Henry Ford telephoned Edison's son and asked if he could capture the great man's last breath. So he placed a rack of test tubes by the bed and stoppered them when Edison slipped this mortal coil. Unseeable, untouchable, the imagination that was activated by nothing. That nothing could engage the imagination. Communal imagination. That nothing could be everything. A relic from one of the greatest concerts I have seen in my life. My connection to a woman touched by the hand of God. Dr Nina Simone. At some point in time I figured it must have perished, and the thought of that was too much to take. I preferred the idea of it being there than knowing it had rotted. A kind of Schrödinger's cat. I didn't want to know it wasn't there. I remember looking at images of the Loch Ness monster and Bigfoot and the Cottingley Fairies in class when I was 7 years old. The atmosphere changed in the room. How could you ever question their validity or want to know they weren't real? I would derive much comfort imagining the gum silently sitting there in the towel in the bag, waiting for some sort of communion. I thought each time I opened it some of Nina Simone's spirit would vanish. In many ways that thought was more important than the gum itself.

There it was.

I looked at it and had this moment of realisation that some day, when I'm not here, this sacred thing is probably just going to end up tossed in the bin. The exhibition seemed an unexpected opportunity to get Nina's gum out of my orbit, as if I'd had it long enough and I was being asked to let it go

for a greater good. To pass it on. It felt time to put it back in the world. I wasn't really thinking at that point what it meant, or could mean, to anybody else. For me, I just always had it as something personal, placed with other totems that pushed me when the cupboard was bare. The invisible forces. Faith and hope. And Nick seemed thrilled to have it in his exhibition: 'It's essential, Was!!' he told me over a pot of Lady Grey tea in the Retreat studio in Ovingdean a month later, working on a soundtrack for his exhibition.

6.

I'm not sure when I became aware of Nina Simone.
Possibly the late eighties. My younger brother Murray had
some albums. I had seen the video of her performing
'Revolution'. The first piece of music I heard of hers was
a version of 'Who Knows Where the Time Goes' on the *Black
Gold* album. I found the album *Emergency Ward* in a bargain
bin in the late eighties, unaware it was from the seventies,
unaware of her prior recordings. It contained these incredible
interpretations of 'My Sweet Lord' and 'Isn't It a Pity'.

I was walking out of a concert in 1992, it was Prince
when he played an unannounced show, and I was off my
head. I was about to walk across the road outside the Palace
in St Kilda, Melbourne, and I felt this hand on my shoulder.

'You're too good a fiddle player to get yourself run
over,' and it pulled me to the curb.

'Thank you,' I said as the cars whooshed past.
'Who are you?'

'Mick Geyer. I've seen you playing around town. You're
not bad. What music are you listening to at the moment?'

'*Lawrence of Newark* by Larry Young,' I replied.

He smiled. 'Want to come over to my place and listen
to some music? It's not far from here.'

That evening Mick introduced me to Nina Simone's
earlier work. He played me 'Wild is the Wind' and 'Sinnerman'.
Until that moment I thought Bowie's was the original
version of 'Wild is the Wind'. Mick wore a suit that smelt of
tobacco, and had the most regal of mullets. His apartment,
a penthouse-style lodging, was lined with books, VHS videos,
cds, cassettes and vinyl long-playing records. He loved holding
court in his eyrie off Fitzroy Street, sharing his love of all
things. Sharpened 2B pencils on his desk and a piece of paper
always in reach. He had ink scribbles on his left palm to
remind himself of things. His recommendations were followed
by a deep drawback of Camel smoke.

People like Mick, the aficionados who had that immense kind of knowledge, who were generous enough to pass it on to you, were really invaluable to someone like me, because they seemingly spent their lifetimes reading books, watching films, listening to music. Observing. Refining. Drawing threads together. They had this incredible radar for greatness. Mick was that guy. 'Have you seen this film? Have you read this book? Have you heard this?' And I hadn't. And I did. Mick was a walking Wikipedia with soul. He could talk politics, Abbas Kiarostami, cricket, John Coltrane, Australian rules football or Lorca with the same passion and enthusiasm. He wasn't trapped in the past, and was curious about the latest offerings, interested in the long haul of the creative life of an artist. He grew up in Sunbury, a western suburb of Melbourne, and he told me the story of when his friend's mum, Mrs Palmer, had loaned her son Barry's school satchel to a roadie who knocked at their door in 1975, asking on behalf of a guy named Angus who played in a band and had forgotten his and needed one for the concert at the local Sunbury Festival. I don't know if this particular roadie was part of the legendary fracas that took place on stage between the Deep Purple and AC/DC roadies, but apparently Barry's satchel was returned the next day.

Mick played me Nina Simone's earlier work that evening and targeted songs that I should immerse myself in. He played me live footage of Nina Simone he had recorded from the television, or copied from other VHS cassettes. He had an intricate system for making duplicates. His kitchen pantry had a VHS collection, not food. He had *The Age Green Guide*, the weekly TV supplement in the Melbourne paper *The Age*, indicating the upcoming week's programming. It was printed on green paper to distinguish it from the main paper. Mick would religiously underline everything to watch and then programme his VHS recorder. He started giving me tapes of her albums and compilation tapes. There were songs by other artists on these tapes you just could never find unless someone dug through some hidden crate in New York or

somewhere, and found one of those small pressings that were out of circulation. He introduced Karen Dalton to Melbourne. He played me Van Morrison's *Veedon Fleece*. His radar was wide but his taste refined. He seemed to know more about the creative process than those involved in it. Mick wrote you letters, stamped them, put them in the mail box. Some records you knew existed, but could never hear them. And the promise of those records was enough to keep you believing you would hear them one day. Mick had these records.

Mick would make you step up to the plate in conversation, always playful and curious. He had this relationship with many people. We would have these music playoffs; we'd play each other music we loved, and push each other around: 'What do you think of this? What do you think of that?' I had no cashflow, as it were, to purchase records. I'd sit in his apartment, learning amidst the aroma of Camel cigarettes, red wine and Nescafé instant coffee. Three level teaspoons and a shot glass of hot water.

You couldn't just look up 'Nina Simone live in '69' on YouTube; there was no internet, no information superhighway. You had to know how to access such things. You had to be shown by people. I would spend hours with Mick, learning. The dearest friend. He had worked as a DJ at a local community radio, PBS in St Kilda, which I listened to and learned. He would make video cassette compilations of short films and performances. There was always this exchange of knowledge with him. Expanding the dialogue about these things had a profound effect on me, creatively and as a person. I would meet Nick Cave through him over a dinner he arranged in 1994, when Nick asked me to come in the studio for a recording session that became *Murder Ballads*. Mick and Nick would drive to Brisbane on a road trip after those sessions when I was on tour with Dirty Three, join us on stage to sing a few numbers, and we made a road trip together down the East Coast to Melbourne. At the end of the trip Nick gave me a piece of paper with his telephone number in London and said, 'Give me a call if you make it over to Europe.'

The idea of seeing Nina Simone live was never something I even thought would be possible. Nina Simone was the divine incarnate. She seemed so out of reach. Like seeing Alice Coltrane or John Coltrane or Beethoven or meeting Tarkovsky or witnessing the 'I have a dream' speech by Dr King on the steps of the Lincoln Memorial.

I had relocated to Paris in 1997 after leaving
Melbourne in 1995 with Dirty Three. I had become a member
of the Bad Seeds along the way after I had called the number
Nick wrote on a piece of paper that I had kept in my briefcase.

And, unbelievably, I got to see Nina Simone in concert
on 1 July 1999, in London. Nick had curated a knockout lineup
of performers for the Meltdown Festival at the Royal Festival
Hall on the South Bank of London. He lovingly referred to
them at the time as his 'Collection of assorted nutcases from
the world of music and acting and spoken word':

- Sacred & Profane
- Blixa Bargeld
- Charlemagne Palestine
- the Bad Seeds
- Barry Humphries invited Sir Leslie Colin Patterson
 and Dame Edna Everage with Kylie Minogue
- Lee Hazelwood
- Jimmy Scott
- Harry Dean Stanton
- Diamanda Galás
- Billie Whitelaw presenting an evening of
 Samuel Beckett
- Dirty Three on a bill with an Estonian ensemble
 playing Arvo Pärt selections
- Hal Willner's Harry Smith Project
- Germaine Greer
- Nina Simone

I think Suicide were meant to open for her, but for
some reason they didn't show. I'd seen Alan Vega arrive at
an A.T.P. Festival in Butlin's I was curating with Dirty Three
in 2008 to play a solo show. He opened the car door and said
to his tour manager, 'You never said it was in the country,

Enrico. What the fuck have I got to do with cows? What do I want with cows?'

Enrico had no answer.

Alan Vega was fearless. Except maybe when it came to cows. So I guess it was the cows or something as to why Suicide didn't appear. I bet Marty Rev is OK with cows. I remember watching Suicide play at some festival in Barcelona in 2008. Nick and I walked over after a Grinderman set to watch them play their eponymous album. In the encore they played 'Dream Baby Dream'. Nick turned to me and said, 'Really hits you in the heart, doesn't it.'

8.

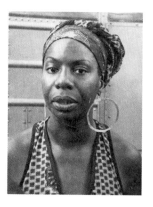

21 February 1933, Eunice Kathleen Waymon was born in Tryon, North Carolina.

The sixth of eight children born into poverty.

She aspired to be a concert pianist.

She was denied admission to the Curtis Institute of Music in Philadelphia. She attributed this to racial discrimination.

1954. She changed her name to 'Nina Simone' to disguise herself from family members, having chosen to play 'the devil's music'.

She was told in a nightclub that she would have to sing to her own accompaniment, which effectively launched her career as a jazz vocalist.

1959. Her first recorded album was released.

Nina Simone went to Montgomery, Alabama, in 1965 and warned the Reverend Martin Luther King, 'I'm not non-violent!'

Three days after King was assassinated in 1968 she performed 'Why? (The King of Love is Dead)', a fifteen-minute song that was written a couple of days prior. The same woman who took a mere hour to write 'Mississippi Goddam' in response to the assassination of Megdar Evars in 1963

and the 15 September 1963 bombing of the 16th Street
Baptist Church in Birmingham, Alabama, that killed four
young black girls and partly blinded a fifth. She said that
the song was 'like throwing ten bullets back at them'. As the
1960s drew to a close, Simone tired of the American music
scene and the country's deeply divided racial politics. Having
been neighbours with Malcolm X and Betty Shabazz in
Mount Vernon, New York, she later lived in several different
countries, including Liberia, Switzerland, England and
Barbados before eventually settling down in the South of
France. By the nineties her life seemed shrouded in hardship
and turmoil. People knew that things were difficult for her
in the South of France. There'd been reports that she'd fired
a gun at her neighbours. There was obviously a lot of distress
going on in her life. She was a very complex character.
She was always explosive and outspoken, but now her career
was winding down. She represented so much to so many,
but her health was seriously deteriorating, both physically
and mentally.

I remember reading about a moment in her life in
the mid-sixties when she got really depressed. Someone told
her, 'You know, you're carrying the weight of everybody on
your shoulders. It's normal that you should crack up.' That we
were about to see her perform in 1999 was a miracle.

Nina Simone was interviewed on BBC *HARDtalk*
by Tim Sebastian a few days before the concert. It's the most
wonderful interview. She appeared majestic, noble, terri-
fying, sensual, in control, worn down, a goddess. Always a
monument. She stopped the interview midstream.

'I need a cigarette. You're making me hot,' she said to
the completely enamoured interviewer.

A nervous hand holding a cigarette lighter appears,
the owner's body off camera, while she takes a cigarette from
the pack. The lighter burns the trembling hand and disap-
pears off camera. 'I'm ready!' she screams playfully. And the
lighter reappears.

9.

The day of the concert, 1 July 1999, I'd heard via David Sefton, the director of the Meltdown Festival, that there would only be a guitarist, a percussion player and a drummer performing with her. Nina Simone would be on the Steinway. He'd heard a rumour that she'd fired the bass player on the plane on the way over. I emailed David in April 2020 for his memories of the show and the technical aspects of the production:

The first thing I remember was the letter of agreement and the instruction to 'Always refer to the Artist as Doctor Simone' – 'Dr Simone's limousine must be no more than two years old'. On the day of the gig myself and Ed Smith (Head of Production) decided that we'd better do this pick-up ourselves so went to the airport (pretty sure it was Gatwick – it definitely wasn't Heathrow). We had arranged to meet the driver kerb-side before Dr Simone's plane landed.

In a pitch-perfect demonstration of Sod's Law, the one time the age of the vehicle was cited in the rider was the one time they sent a shitty old box stretch limo that screamed 'low rent 1970s Las Vegas wedding rental'. It was a totally inexplicable act on behalf of the car company – or the gods – or both. Ed and I were both mortified and terrified in equal measure – it was too late to do anything about it and there was no way on earth this car was any less than 20 years old, let alone two. After a long and tortured wait, Dr Simone appeared, wheelchair being pushed by one of the coterie of young gay black men that we were to come to know as her staff. We were braced for the worst. She said nothing. Didn't even notice. And away she went. I think the sensation of terror and anticipation of that pick-up will never leave me.

So the whole staff were braced for a horror show that for the most part never materialised. Absolutely everything she'd asked for had been done; we all bent over backwards to

accommodate her every whim. We literally left her nothing to complain about. She was a formidable presence – no question about that. I had the fantastic and unforgettable experience of witnessing her bawling-out one of her own staff who made the serious error of judgement of reintroducing me to her. 'Of course I know who this is,' she gloriously bellowed at the poor bastard. I was hands-on the whole time just to make sure absolutely nothing went wrong – and it didn't. I'd hate to have seen what happens when things didn't go to plan.

Her rider also included very clear detail of a room she could retreat to right next to the stage – this required us basically building a shed (that was then dressed) so she could come and go from the stage during the performance.

Other rider requirements I remember included: "Six bottles of Cristal for personal use."

I read an article in the *Guardian* from 2017 entitled 'The day I shared a bubble bath with Nina Simone' by Michael Alago in which he states:

Nina and I remained firm friends until the end of her life, 12 years later. The last time I saw her was in 1999. Nick Cave was programming the Meltdown Festival and had asked Nina to play. I flew to London on the day of the show and went straight to her hotel with a bottle of champagne and two dozen white roses – her favourites. The room was full of people, she was having her hair done and it was all hectic.

Nina shouted: 'Everybody out, except Michael!' and suddenly we were alone. 'Sugar lips,' she said, 'I know you're gay, but I think it's time for a bubble bath!' So the next thing I knew, she'd stripped down, I was in my boxer shorts, and we were in a tub full of bubbles drinking champagne and laughing like teenagers. And that's how I will always remember her.

My friend Matt Crosbie, who mixes the front of house sound for Nick Cave and the Bad Seeds, Dirty Three, Cat

Power – he's mixed the Bad Seeds for a quarter of a century now – was mixing everything for that festival. He's the only person I know who ever spent an hour alone with Nina Simone, during the soundcheck on the day of the show. I called him on the telephone.

'Hey, Matty, it's Woz. I wanted to ask you some questions about that Nina Simone concert we saw in '99. Do you remember it?'

'Of course I fucking remember it. Religious experience. You were there!!'

'What happened during soundcheck?' I asked. 'What did she talk about?'

'As I recall it, she just sat there at the piano playing on her own, then stopped playing, and demanded to know, 'Who is doing the soundcheck? It's the best-sounding piano I ever heard.'

He identified himself as Matt Crosbie and she said, 'Matt, you come down here.'

He left the mixing desk and made his way nervously to the stage. He knelt at her feet, in deep awe, and she was, according to him, 'kind of pissing in my pocket' about how great the piano sounded. 'That's a goddamn piano sound.'

She told him what she wanted in the monitors: 'The drums are not loud enough and I need some guitar. My voice needs to be loud. I want it clear, Matt.'

Playing on her own, she left the band to sort things out amongst themselves. Matt went back to the front of house then worked the band in the mix after they plugged in. He noticed a bass amplifier standing unused and asked, 'And what's going on with the bass player? Is there one for the show?'

She interjected, 'No, Matt, I sacked that motherfucker at the airport on the way over from Paris. I'll do the bass with my left hand.'

'Then she ran through a couple of songs with the band and it sounded fucking unreal,' Matt continued. 'I was

a long way from mixing at the Hopetoun Hotel in Sydney, early eighties, Woz. You know what I mean?'

After soundcheck, Matt went and had a couple of pints of Guinness at the bar in Festival Hall, which he christened 'the Departure Lounge'. He came back and passed by her dressing-room, 'the shed', which was off-bounds to everybody. Everyone was afraid of her. Matt, he told me, was sort of put in charge of Nina. He knocked on her door to give her a thirty-minute to curtain warning. She invited him in. 'She was just sitting in there in a wheelchair. With another woman.'

'Come in, Matt,' she said.

'Doctor Simone, is there anything else you need? Anything that I could get for you?' Matt asked.

According to Matt, she perked up and replied, 'Well, Matt, since you're asking, can you get me some champagne, some cocaine, and some sausages.'

'Nina, I think I can get all that. What sort of sausages would you like?'

'I don't care, just some goddamn sausages.'

Matt went and got 'a gram of cocaine somewhere within the compound, a bottle of Moët champagne from the bar, and half a dozen assorted sausages from the kitchen at the Festival Hall'. He took these to her room and she thanked him, then he got himself 'a pint glass full of whiskey with a splash of soda' and returned to his mixing desk for the concert.

'So all that happened thirty minutes before the concert, Matt?'

'Yep.'

10.

I entered the main room in the Festival Hall. Possibly around the time Matt delivered the champagne, cocaine and sausages. Nina Simone was the penultimate concert for the festival. I'd seen so many other performers here and I'd played the room myself several times. I had watched Barry Humphries masterfully top and tail his show with a pianist, switching between his characters of Dame Edna and Les Patterson at the flick of a switch. I'd seen Harry Dean Stanton soundcheck, Charlemagne Palestine set his teddy bears up on the piano, and spoken to the beautiful Jimmy Scott as he positioned his hairnet between soundcheck and the concert. He called everyone, 'Darling.' The most divine man. But the venue seemed entirely different this night. It had shifted somehow with the anticipation and the palpable reverence in the audience. It's not unusual for a performer to be nervous about a show. But here, the audience was nervous.

I took my seat next to Mick Geyer. He had been present the entire festival, assisting Nick with proceedings. He was in his element and had an aura of anticipation. The seats felt like they were graded much higher and everybody was just leaning in and looking onto the stage. I felt like I was going to fall over walking to my seat. And it was so hot, it felt like the room was on fire, and you could see and feel this look of expectation on everybody's face, this grand anticipation, this communal coming together, an acknowledged feeling that whatever we were about to see would be an experience nobody ever planned on having.

I kind of watched Germaine Greer read Sappho as I found my seat. Then Nick appeared and introduced Dr Nina Simone, his face etched with measured disbelief and awe. He was wearing his prescription glasses, which struck me as peculiar as I had never seen him wear them on stage. He looked fresh-faced and scholarly. Like he was the responsible one. She appeared on the side of the stage. Smoking a

44

cigarette. There she was. She moved painfully into the wing.
It was obvious that moving was difficult and she was unwell.
My friend Jerry who was also there, he claims she was in
a purple skirt, and she arrived at the side of the stage on a
Zimmer frame. A walker. I don't remember that aspect of it.
She was wearing a white top. I remember thinking she'd taken
the duvet from the hotel bed and sort of tied it around herself.
Which obviously wasn't the case. It was this really strange
formless top. It was billowing everywhere. She had this gold
stripe of make-up across her eyes, like something out of
ancient Egyptian royalty. Her hair was cropped short and
deep red and she was obviously struggling to remain upright.
I can't remember if anybody helped her.

When she appeared side of stage, she was chewing
gum, which I thought was the coolest thing ever. Mick dug
his elbow in my ribs. She was just standing there, chewing
with this look of tired defiance on her face. There was no
smile. She looked mean. Staring at nothing and everything.
She looked angry. She looked in pain. Smoking a cigarette
and chewing gum. I could see Bleddyn Butcher with his
camera 'right in front, if I recall correctly, crouched between
paying customers' shoes and the lip of the stage'.

The crowd got to its feet when 'Dr Nina Simone' came
from Nick's mouth and she moved onto the stage slowly.
People were clapping, crying, screaming, ecstatic. I had never
felt energy like that in a room. It was unfathomable to think
we were in her presence. Those moments you don't believe are
real. When you know life will never be the same after.

Finally, she moved forward, came to the front of the
stage, and you could feel everybody craning in; this weird
domino effect. The hall is actually on a flat level mostly, but
it felt like we were all perched in some Roman amphitheatre
that evening, everybody craning forward like they were
going to topple over each other willingly. I could see flames
surrounding me and the sound of the room was like when your
ears burst when the plane starts its descent and you sweat.
I could see Nick had made his way to the side of the stage.

With great difficulty she walked to the front of the stage and she just put her clenched fist up in the air and just went, 'Yeah!' Just like that. And I think there was this kind of reply, like a 'yeah!' back, back to her. I remember nothing came out of my mouth as I attempted to reply. And then she did it again: 'Yeah.' The sound of two thousand people gulping and their breath being sucked out of them.

Matt Crosbie remembers she angrily said something about staying away from England for twenty years and being outraged that she 'checked into the hotel and black women were still cleaning the rooms'. She was staring everybody down. I had the feeling she loathed everyone. It was the most powerful thing I've ever seen, terrifying and awesome. And then she walked over to the piano, sat down with great difficulty and wiped her brow with a towel that was positioned on top of the piano. She placed the towel on the left side of the piano, next to the bass keys, put her fingers to her lips, took her chewing gum out of her mouth and pushed it on the piano. I clocked that straight away.

She raised her fists and started playing. Hammering the piano. I can't remember what the first song was. Maybe 'Black is the Colour...' Maybe only her and the piano. The band watching on.

She was hacking away, trying to sing. It was almost painful to watch. She was struggling to hit notes. She looked pissed off. Reaching for something. Hammering the keys violently. You could sense the audience hanging on to whatever they could, to will her on. Heartbreaking and apocalyptic, like watching a car crash.

At the end of the song she got up and walked to the front of the stage again and put her fist up in the air, and gave this 'yeah!' again. And there was some sort of semblance of a softening in her face. Something shifted. She went back to the piano and sat down. She launched into the second song and the most incredible transformation took place. Her voice lifted and she seemed reborn. She pounded the keys and her voice railed in defiance against her body. You could see her

acknowledging the audience's screams and adulation.
You could see her absorb it, fuelled by it, tapping into the
genius that had defined her all her life. A total transformation
and transcendence beyond the physical kind of problems
she was having; shed of her physical problems, some inner
force taking over. Summoning herself to her own rescue.
Dr Nina Simone.

I remember a version of 'Pirate Jenny' that was as
aggressive as anything I've ever seen. The band hanging
on for dear life. By the end of the concert she was dancing.
She was in front of the piano, sort of spinning around,
dancing, smiling and blowing kisses to the audience. I can't
recall much of what she played. I remember she sang
'Here Comes the Sun', and 'My Baby Just Cares for Me' was
possibly the encore. I think she introduced this by saying,
'I know this is what you all want to hear.' She finished
the song then walked to the lip of the stage and raised her
fist in the air. The look on her face was everything. And then
it was over. She was gone.

The lights came up and the room seemed suddenly
normal. People were in shock. Faces wet with tears, not
knowing where to look or how to speak. We had witnessed
something monumental, a miracle. This communion that
had taken place, between her and us. This concert that
would inform our lives for ever; to have been in her presence.
To watch her transformation was a religious experience.
Spiritual.

I left my seat as people left the room, and made my way to the stage. I hoisted myself onto the stage. I headed for the piano to see if her gum was still there. Seated in the audience I'd thought she had stuck it on the piano, in fact it was on her towel. I folded the towel over the chewing gum and I walked away with it. I arrived in the green room and whispered to Mick Geyer what I had under my arm. Mick gave me a yellow Tower Records bag he had vinyl LPs in, at the aftershow, and I put the folded towel with the gum inside in the bag.

I called Matt Crosbie twenty-one years later. I've sat on thousands of buses, planes, in hotel lobbies with Matt and I had never asked what happened after the show. He spoke down the telephone from his shed in Tasmania:

'Fuck, do you remember that?! What a show. Do you remember everyone's faces?' he said. 'My back was sore from everyone punching me. Ian Johnston, Daniel Miller and James Johnston were behind the mixing desk. I turned around to look and everyone was crying. A religious experience. Fucking devastating.'

According to Matt someone from 'her people' came to the mixing desk when the show was over and asked him if he had recorded the concert. He had and they asked for the DAT tape. The only recording of the concert. Later a version of 'See-Line Woman' from that show appeared on a live compilation album. 'I know it's my recording because the bongos are so fucking loud. Straight in the desk, down the guts to DAT.' It's the only known recording released from the concert. The remainder has never been released.

He went back to see her after the concert.

Matt: 'Here's one for you, Woz. My friend Jenny Higgie wanted to come back and meet her. I said I doubted it, but we'd give it a shot. We got back to her room and it was empty. Half a line of coke on the table, no champagne and the

sausages were gone. I helped myself to the coke, as you do. I think Jenny took the empty bottle of champagne home from memory. I know you took her gum from the piano. Do you still have the gum?'

Warren: 'Mate, I still have it. It's on display now in the Royal Danish Library in Copenhagen at Nick's exhibition.'

Matt: 'You're fucking kidding me?! How unreal. Fuckin' legendary.'

Warren: 'I might reach out to Jenny and try to do a double act with the gum and champagne bottle. I'll ask our friend David Noonan.'

Matt: 'Well, check with David Noonan, he's close to Jenny. He will know the story. What a devastating show. I'm crying now thinking about it. You know how it was. You were there, Woz.'

There seems mixed information about the bottle. I texted David Noonan with the idea of uniting the gum and champagne bottle at some later time. David told me Jenny 'actually took Robert Smith's champagne glass at the aftershow'.

12.

In February 2020 I searched the internet for images of the concert. Zero. There was nothing beyond the image of Nick and Nina Simone backstage taken by Bleddyn Butcher. There were no iPhones or smart phones back then, or digital cameras. No one was really taking shots at a concert except the professionals. There's no live footage as far as I know. I found a performance from the same year, 1999, and she is wearing the same outfit. It's some television series called *Music of the Millennium*, celebrating the pop hits, and she performs 'My Baby Just Cares for Me'. There is an interview that follows the performance:

Host: 'Doctor Nina Simone, it's such an honour to have you here tonight. I want to ask you, please could you tell us, the British people love you. Please tell us probably what your most memorable performance in the UK was for you?'
Nina Simone: 'The Royal Festival Hall and Royal Albert Hall.'
Host: 'Yeah, what was it that made it so special for you?'
Nina Simone: 'The audience, their enthusiasm.'
Audience cheers.
Host: 'See, you show your love, she shows your love back. You see the charts, some of the charts on the *Music for the Millennium*, if you had a chance to vote, who would be one the great artists for the millennium?'
Nina Simone: 'Maria Callas…she has been my inspiration, she and Mary Anderson have been my inspiration since I was 3 or 4 years old. And my first love is classical music.'
Host: 'And out of the new wave groups out there, you got Backstreet Boys, T.L.C., all the new groups. Who do you admire out of the new groups out there today?'
Nina Simone: 'I DON'T.'

Host: 'Ladies and gentlemen, DOCTOR NINA
SIMONE.'
Thunderous applause and Nina Simone beaming.

It's all the more wonderful that this Festival Hall
concert only exists in the memories of the people present.
That its witnessing wasn't a twenty-first-century
phenomenon, loaded with iPhones and furious texting while
the performance was taking place. From the stage Nina
Simone would have only seen the people's faces. It's only
grown more unreachable and epic over the years and its
communion can only be re-lived by the telling of the story
by word of mouth. The passing on of the imagination
and the holy.
I emailed Bleddyn in February 2020, enquiring
if he had any photos of that concert beyond the photo with
Nick before the show.

Bleddyn
I was just looking at that image of Nina Simone
and Nick from the Meltdown concert in 1999.
I wondered if you have any of her performing
that night? Any of her chewing the gum?
That would be a holy grail of sorts.
Any of her putting it on the towel?!?
Sending love and rain.
Warren x

Dear Waz,
I do have (live) photos of Nina from that champagne,
cocaine and sausages evening – one I just discovered recently
(post-Dirty Three@Opera House anyway) of her raising a
clenched fist in the air (probably acknowledging applause at
end of concert), which I was very pleased to discover. There are
others as well, which I can re-check. I remember being

rather disconcerted by her outfit at the time, which may've
prejudiced me against looking closer in the past. I'll send what
I have to hand in the morning and scour the archive for a
chewing pic on the weekend, say. The pic of her with Nick is,
of course, readily available.
> *More soon.*
> *Love,*
> *Bleddyn*

> *Dear Waz,*
> *Attachments are an all-but-exhaustive sketch of the*
two half-rolls from Meltdown. There are several versions
of the clenched fist (two included here) but I think 8.28a might
be the best. Was a little surprised to discover an even closer
pic of Nina singing at the top of her voice (I think 9.16a is
my favourite but 9.17a may be preferred). Shot from balcony
is the only one I took during the whole two-week festival
– was this the box where you watched her performance from?
Loved your description of her costume as a duvet dragged from
her hotel room and wrapped around her with a belt, by the
way. Best comparison I could come up with was the fringed
wrapping paper Christmas cakes come in.

> These are amazing, Bleddyn.
> Was I in the balcony?
> I have no idea. I thought I was middle, a few
rows back.
> And had the impression I was leaning in.
> But maybe you're right.
> Funny how the mind changes things.
> Woz xx

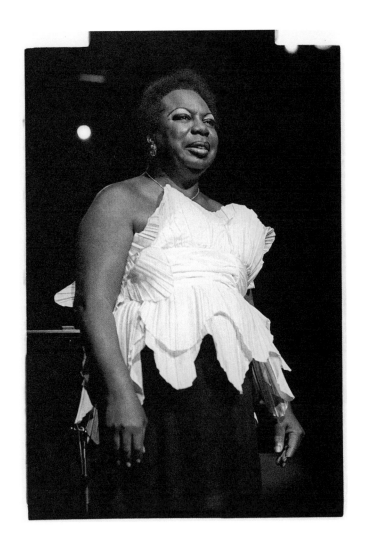

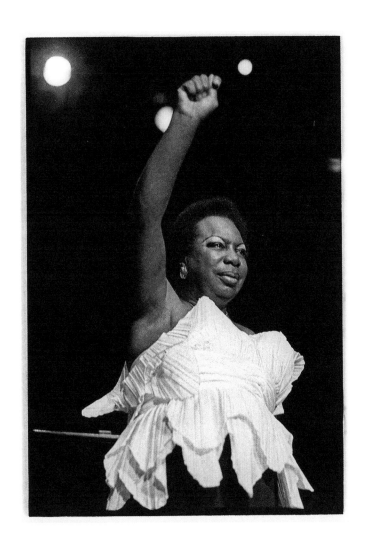

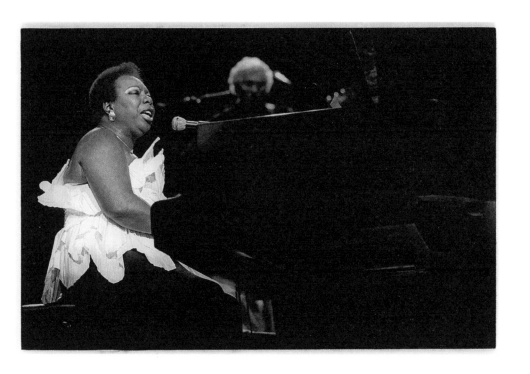

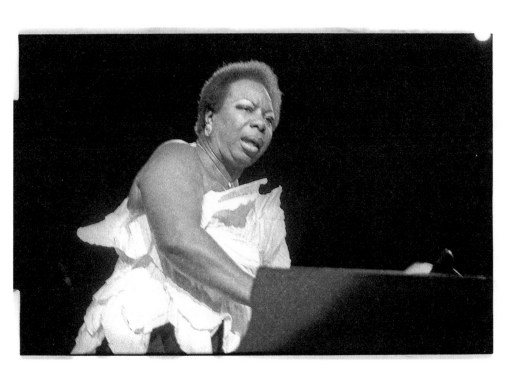

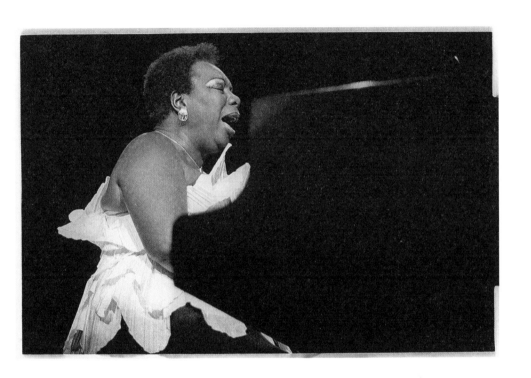

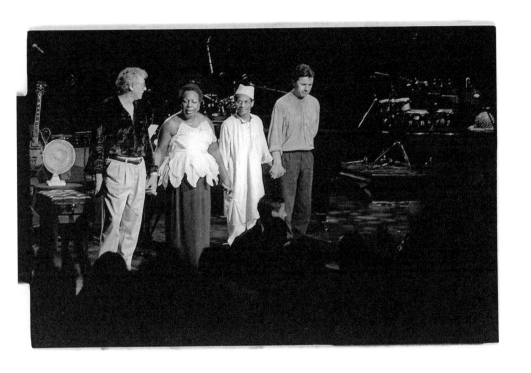

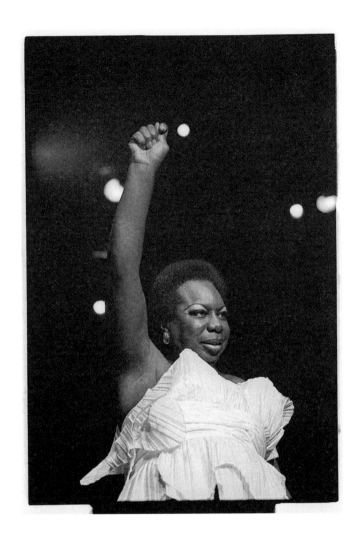

13.

I went back to my hotel after the concert of Nina
Simone, I guess, and placed the Tower Records bag, with the
towel and gum inside, in my Samsonite briefcase.

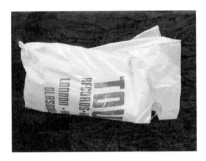 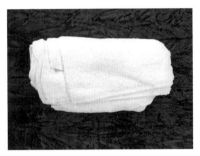

I would take it on tour with me. From the moment I took the
gum, I never touched it or tried to move it from the towel.
I looked at it maybe once or twice in the hotel room. I didn't
show it to anyone or mention it in conversation. I figured the
fewer people who knew about it the better, and I also didn't
think anyone would be interested, to be honest.

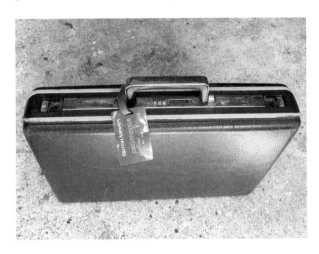

In those days I always carried a briefcase with me.
After the nineties it became a computer bag. It started
when I first began touring, when my world became mobile.
I was rootless and this was a way for me to contain an
environment. A portable shrine. There's a particular model of
Samsonite from the eighties that I like. The Executive Model.
Dark brown, espresso, with a chrome handle, rounded edges.
Not the square variety. Slim. Made before laptop-inclusive
was a selling point. I saw one in a movie and it spoke to me
of this other world. An exciting world. I remember owning
several of these briefcases. They were like little personal
museums that I could carry around with me. Everything
precious went in them. They are scattered around the house
because I would need to retire them. I'd get stopped in
customs. Sniffer dogs generally put them to bed. I remember
customs in Australia taking offence to a piece of bread I had
in the shape of a heart, the size of a baby's thumb, that my
wife gave me, and I was detained for hours because I hadn't
declared I had food items. After measuring it with a ruler
they decided it was illegal to bring into the country as it was
5 millimetres larger than the minimum size permissible.
It was placed in a large plastic bag and confiscated. I was
fined for illegal substances and a false declaration. I paid the
fine and left. What they were looking for was under my
watch strap.

I found the briefcase in a hallway cupboard, twenty
years later. 6 February 2020. Unchanged. I opened it.
It resembled the bottom of a handbag.

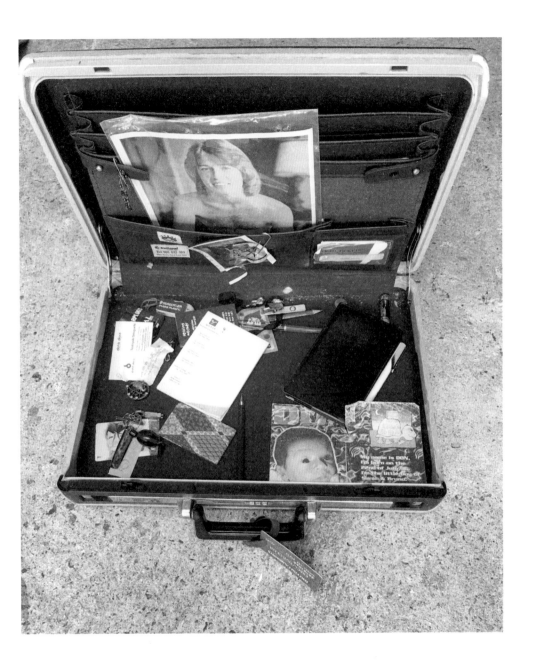

There's a photo of Mozart playing a violin that my friend Noah Taylor had taken when he was working on a film, *Shine*, about an Australian pianist David Helfgott in '95. It's a sculpture in Vienna of Mozart wielding the violin around unceremoniously. Noah gave me this photo and said, 'Man, he's ripping you off.' I found a photo of me performing at Meredith Music Festival in 2004, the night of the great storm that threatened to wash the whole thing down a valley.

Noah had a point. As the lightning cracked above the stage and the black clouds rolled up the valley I turned to the promoter Matt High and I asked gingerly, 'What do you advise?'

'Mate, the anvil has arrived. Play until the power is cut.'

He had a point.

I emptied the briefcase on the floor. Inside it was:

– photo booth images of people I couldn't remember, people I could
– a brooch in the shape of bagpipes that my grandmother used to wear on a kilt, or something
– a cross that I'd purchased in Milan in 1988, given to my mother then she gave it back to me in 1996

- a heart-shaped stone that had been given to me by my future wife, Delphine
- an empty notepad
- a rusted pocketknife with an amber keyring I bought in Athens
- a photo of Andy Gibb someone gave me
- a 64kb Sharp Zq–3250 Electronic Organiser
- unfiled tax form from 1997
- a fax number for Nick in a hotel in Morocco
- unsigned Mute Song publishing contract from Andrew King
- a photo of a friend's baby
- a silver pendant
- a broken silver chain
- a gold *diamanté*-encrusted broken violin brooch
- a silver frog from a violin bow with intricate designs carved in it
- cassettes from Mick Geyer labelled 'flutes 'n' all'
- an Aiwa Walkman cassette player
- membership card for Motel 6
- a letter from Jonathan Richman telling me how to mic up the band for the next recording based on The Who concert that he saw in 1969 with the drawing of the band and microphones
- a poem from Jonathan Richman about Dirty Three
- a green ballpoint pen from a hospital in Munich
- some plastic sachets of Attiki honey
- a very dried piece of lemon
- running list for *Horse Stories* album
- admittance form to a hospital in Munich dated 1996
- sachets of Nescafé instant coffee
- a red Japanese address book
- an *omamori* 御守 from a temple outside Yokohama, which I visited with Delphine and her Japanese mother
- a book I've never read
- an eraser

- a mostly empty 8 fluid oz bottle of GLOCKENGASSE
 no.- 4711 Ice Cologne
- a 2B Staedtler pencil
- bits of paper that were worn white
- Theosophical edition of *Notes on the Bhagavad-Ghita*
- a message from a fortune cookie
- a plastic Japanese rabbit pounding *mochi* 餅, もち
 with a pestle on a red thread with a bell attached
- a spoon from an American diner
- a postcard from Dave McComb
- seven gold dental crowns and inlays and two teeth
 in a Redheads matchbox

I remember being in a car in Los Angeles with
Nick driving to a meeting with Guillermo del Toro in
the early 2000s concerning a score for a potential stop-motion
adaptation of *Pinocchio*, drawn by Gris Grimly. As we pulled
up, Guillermo, who I had never met, was walking down the
path towards the car, his smile visible from a hundred yards.
He opened the door and clocked my briefcase. His already
glowing face softened more. And his eyebrows rose above his
glasses.

'I love those briefcases. I had one in the eighties when
I was a student. I had one when I met my wife. Can I carry
it inside?'

'Of course you can,' I replied, handing it to him.

We followed Guillermo into his house, I guessed
it was, or his production office, and sat around a large table.
The interior of the house was like a museum of every kind
of monster and curiosity imaginable. Skeletons, ghouls,
mermaids, props from films, pages from books. I opened my
briefcase to grab a pad and I saw the gold crowns and teeth
rattling around, freed from their matchbox. I had an idea.
I threw the idea out there, that we could make the percussive
aspect of the score using teeth and prosthetic limbs, glass
eyeballs, wooden legs, and drop some melodies on top. This
was greeted with enthusiasm. We discussed the script and

the project. After the meeting Guillermo turned to me and said, 'Could I carry your briefcase to the car?' I watched his hand take the handle and his face broaden and composure shift. He carried the case to the car and handed it to me and waved goodbye. The film never happened.

Our connection to things. The stories they remind us of, and the past places and times they make us land in. Time travel. Connection. Shared stories. I have several of these strange time capsules hidden around the house. They make me think of the wonderful Museum of Innocence in Istanbul founded by Orhan Pamuk. But without a story yet shared. Things that make anywhere feel like somewhere.

Nina Simone's chewing gum spent two years in that briefcase and travelled everywhere with me when I toured. Amazingly it was never subject to security checks and sniffer dogs. When I moved to a new house in 2001 I realised it was way too precious to carry around in a briefcase. I was sure I would lose it. After September 11th I was subject to more frequent bomb checks at airport security and figured the gum would be collateral damage. There was a time when a beard was political. There was no way that was going to happen.

14.

From 2001 to 2004 the Tower Records bag with the
towel and gum inside sat on a 1980s Yamaha U3 upright piano
in my living room. I had been given the piano by Delphine
for my 37th birthday. I decided to try to learn how to play it.
It's something I have done all my life. Get an instrument and
try to make a tune with it. For some reason I draw the line at
brass instruments. I figure every instrument has a tune in it.
How many instruments are there? But there was something
too exposed about it sitting on the piano. I mean to anyone
else it was a plastic bag with a towel in it. A forgotten trip to
the pool. And the bag is bright yellow and begging to be opened
or reused. I hid it under a pile of music books, *The Songs of
David Bowie*, a book of selected quotes from interviews with
Lou Reed, some blank music manuscript sheets I intended
to use but never did. Then I stuffed it inside a ceramic vase
with violet flowers painted on it in the window frame above
the piano. I took the front off the piano and hid it behind the
soundboard. That's where burglars look, I guessed. I took it
out. Where don't they look? The thought never entered my
mind to change the bag. In my mind it was all part of the same
thing. The bag that housed Nina Simone's gum and towel.
I figured it would accidentally end up in the washing machine.
When I was on tour I would have panic attacks about it being
thrown away, oblivious to the fact my wife was well aware
of what it was and was being watchful. We took on a cleaner
who was so efficient. No place seemed safe.

I built a home studio in the attic of the house around
2005. A table and M-box audio interface, a Boomerang loop
station and an iMac computer. There are two small windows
that are oddly shaped in the attic. I placed the Tower Records
bag and its contents in one and built a tiny shrine, a kind
of *kamidana* 神棚 in which I placed:

- a medium-sized bust of Beethoven from a garage sale
- the Tower Records bag and contents
- an unopened compact disc copy of Lou Reed's *Metal Machine Music*
- a black and white photo of my kids playing with the garden tap wearing green gum boots, oversized t-shirts and nappies one summer's day in 2003
- a small statue of the Eiffel Tower (of which I own more than twenty).
- a lead figurine of Ned Kelly
- a postcard of Ned Kelly's death mask from Mick Geyer
- a miniature of the Petronas Twin Towers in Kuala Lumpur

This *kamidana* 神棚 'god/spirit-shelf' window frame in front of the desk, I placed a beige linen curtain in front of it. My first studio, where I started making ideas for the scoring work I would collaborate with Nick on. *The Proposition, The Assassination of Jesse James by the Coward Robert Ford, The Road,* Grinderman. It was the first time I had a place to work. Until then I had worked wherever, with whatever, whenever.

I have two busts of Beethoven. The bust in the window shrine came from a local garage sale in Ivry-sur-Seine in 2002. I had purchased a large bust of a young Beethoven in Budapest on *The Boatman's Call* tour of 1997. It has sat in my bedroom ever since. At the foot of my bed, high on a wooden Japanese cupboard, looking down from high. I've had a thing with Beethoven since the mid-eighties when I was in my early twenties.

I was looking for a violin teacher in 1984 and nobody wanted to take me on. I had auditioned for several and they all rejected me. My relationship to pitch and timing was always very personal. I played a Bach Partita, No. 3 in E major, and *Liebeslied* by Fritz Kreisler for a guy named Phil Carrington, and he took me seriously for some reason. He came up and put his head on my back, placed his hand on my shoulder, and I was mortified. He just said, with his ear to my back, 'You have a big voice and you need to be heard. You aren't afraid of emotion. But you are unable to control it. We need to find the music that suits you. You should be playing Shostakovich, Bartók, composers with broad melodies. This isn't for you, this music. This is not you. You should be playing big sounds that match the big sound of your violin. We need to go back to the beginning.' The very same violin I would take across Europe a few years later, still in search of the music for me to play.

Phil conducted the orchestra at the music college I attended, and that day he also became my teacher. One day he brought in Beethoven's Seventh Symphony, and every time we rehearsed the second movement, it sent me catatonic. I'd never heard this symphony before. I don't think I had ever listened to a symphony. I knew 'Ode to Joy' and 'Für Elise'. The second movement overwhelmed me. Beethoven opened something in respect to connecting with the violin and this music that I'd been playing with no way in. I've had a love of

music since I can remember, but I had no relation to the classical music I was trying to play on the violin. I loved it on the radio. I'd listen to it with my mother in silence over summers in the seventies, not knowing what any of the pieces were titled or by whom they were composed. But there was a sense of quiet reverie in the living room when the classical channel was tuned in.

I was playing the Beethoven symphony with the orchestra during a concert in 1985. It was being performed in a lecture room I had spent hours in. Hours that became days that became weeks. We started performing the symphony. I felt the atmosphere in the room change. It was warm and illuminated, candlelight-like. The air was heavy. It was the second movement. I looked out and became aware of another presence in the room. This glowing form. A figure behind the audience at the back of the room. A spirit. Beethoven's presence in the room. I continued playing. I had an out-of-body view from the corner of the room. Where the wall meets the ceiling. I could see myself playing, the orchestra, conductor, the audience, the spirit. During the entire last movement it just glowed there in the back. For some reason I was at peace with it. There was something calming in it. I told someone I had seen Beethoven during the concert, and they just smiled.

A few months later I was playing the flute in my bedroom in Newport, Melbourne, with my eyes closed. I was seated on the floor without a lightbulb on. The door closed. The cupboard behind me started glowing. I could see it through the back of my head. I could see the shape of the door glowing, the light was inside the cupboard bursting through the cracks between the door and the frame. The same light as during the concert. I always see it in my mind when I think about it. The same intense light when the backyard was full of clowns illuminating the room. The same form that appeared during the concert performance of the Seventh Symphony appeared in front of the cupboard. I had vision through the back of my head. I watched the light-form shoot towards me and pierce my back and pass through my body. I was watching

everything from the ceiling corner of the room. Multiple vision. I watched it come out my lower abdomen. I started screaming. Then I threw up. My housemate found me drenched in sweat lying on the floor, white as a ghost. She had bright red dyed hair and the palest complexion that made her glow in the dark. I told her, 'I've seen Beethoven's ghost and it passed through me.' I lay on the floor with a cushion and passed out.

Then in 1987 I found myself in a hole and decided to decorate it. I was lying in bed, really not doing much, listening to the ABC classical radio station, wondering what to do. Suddenly the atmosphere shifted and this presence appeared again at the end of the bed, the same one as during the concert. It was tall to the ceiling and looking down on me. I couldn't breathe, I couldn't get up, and I couldn't move. I was petrified. It was radiating anger. I could hear the music and my heartbeat pounding in my head and again this out-of-body vision from the corner of the room. Looking down on myself in bed and this entity. I could see everything in the room stereoscopy-like. Then as soon as the music on the radio stopped the presence went away, I was back in my body, and I gulped for air. The announcer said, 'And that's Beethoven's Piano Concerto No. 3…'. I passed out drenched in sweat and slept for hours. I woke shivering in damp sheets when dusk fell.

I took this to be a sign I needed to get on with something meaningful in my life, find a sense of purpose. When I eventually started playing music with a band in the early nineties I no longer woke with the question, 'What am I doing?'

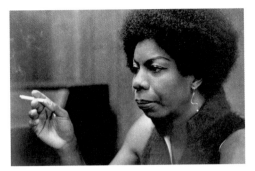

Nina Simone died 21 April 2003.

Her ashes were distributed in several countries.

Mick Geyer died 13 April 2004.

I continued to email him periodically for two years, telling him about music I had been listening to and concerts I had seen. One day I stopped.

16.

When I saw Alice Coltrane play a few years after
Nina Simone, I couldn't believe it. It was that moment again.
Those times you think are never going to happen in your life.
She was someone who totally shifted my world in the eighties
when I discovered a record of hers by accident in some sale
bin. She arranged the kind of orchestral strings I'd always
imagined in my head, this combination of classical and free
form, yet incredibly structured as well, almost like a pop
song. She totally changed how I saw things musically, in the
same way John Cale's viola changed how I saw a stringed
instrument could be used in rock music. In many ways,
Alice Coltrane did what a lot of the other people around
her couldn't do. She took loose aspects of free-form jazz and
contained them into these beautiful spiritual songs. Structure
and freedom. Every recording I have gone into I have in my
own way tried to honour her.

They announced a concert in Paris for 30 August
2005 at Cité de la Musique. Alice Coltrane was at the peak
of her powers when I saw her on stage with her Hammond
organ and synthesizer from her ashram. I watched her walk
on stage dressed in an orange robe with her grandchildren,
who then sat on the organ stool while she played. For the
encore she came out and said, 'Now we'd like to play a piece
John left for us to learn.' And they launched into 'A Love
Supreme'. The audience rushed the stage like a rock show
and started dancing. Her last recordings at the Shanti
Anantam Ashram in Agoura, California, are unbelievable.
I seriously tried to buy her house in 2018. Someone sent me
a link: her ashram was up for sale. I started flipping around,
checking in with people because it was going to cost a couple
of million dollars that no one I knew had. I asked Flea if
he was interested. I just thought this holy place of music can't
be demolished. I wanted to preserve it. But I ran out of steam
because it was so expensive and so far away. And everyone

I asked seemed to have money problems. And then the fires took it in 2019. It just got razed to the ground.

In 2007 I decided to move the gum from the shrine I had built to a wooden chest of drawers in the attic. In a drawer there was a pile of folders with tax returns and receipts. I hid the gum beneath the pile, figuring no one would dig further once they saw those folders. I had thought to build something to house the gum in my new studio that I'd decided to make in 2009, but I was aware that would make it vulnerable and visible. I thought to cut a square out of the pages in the centre of a book but I didn't have one big enough to house the bag and towel, and I was sure I would forget where it was. I knew it needed to be hidden away without drawing attention to it.

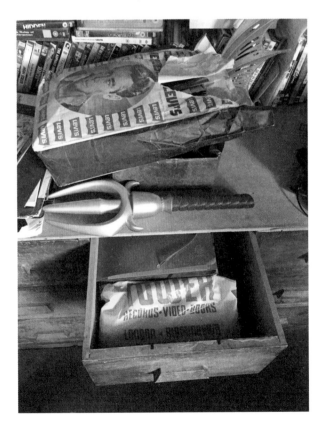

Nina Simone's gum stayed in that drawer until November 2019 when I took it to London to be taken to Copenhagen for the exhibition. I removed it once for an evening while my new studio was being built in the backyard of my house in 2009. There was an old atelier frame I decided to fill in and make a studio. I wanted the gum to be there when the foundations were laid. I took it from the drawer at night and placed it on the cement slab and listened to *Emergency Ward* by Nina Simone, *Universal Consciousness* by Alice Coltrane and Symphony No. 7 by Beethoven.

Alain Brunswick, a metal worker from Montreuil, came to look at the old wooden frame in my backyard with the idea to fill it with iron and glass in 2008, to make my studio. Some friends recommended him to me as he had built many beautiful theatres in Paris and the suburbs. He had retired from work. A lifetime of Gitanes and welding fumes left him poorly. I explained I wanted to build a studio to make music in. He looked at the frame and his eyes sparkled. 'Now this is interesting. This makes me dream. I will build a great cathedral for your music.' I watched him work for three months, mostly alone, struggling with his health. He had his tools, an arc welder, a grinder, a metal saw, a ruler, pieces of paper and a pencil. Not a computer or iPhone in sight. One day he was standing head in hand, cursing. I asked what the problem was. 'I was in a hurry with the handrail on the stairs and I've messed it up. It's crooked. What an idiot.' I looked and could see nothing. I told him it was fine and not to worry. He turned and said, 'But I will know it's wrong.' The next day I found him smiling, having dismantled the day's work and rebuilt it. It was the last work he completed. He still asks me if I use the little windows he installed.

17.

The things we collect are the things that are of
significance to us first and foremost. Outside your orbit and
people connected they have no significance. They're specific
things. These things that are precious to us are really just
precious to us. For some reason I have a hard time throwing
out shoes that have served me well. I had a cupboard full
of worn shoes in the corridor, and eventually I started
photographing each pair to allow myself to get rid of them.
There's a connection there. I can't just let them go. Shoes I
have used only for concerts, shoes that you can't repair any
more, shoes that have been repaired one too many times.
I threw out the shoes. A few years later I lost the photos.

I was in a candy store in Los Angeles in 2008 and
one of my sons had been told he could buy a certain amount
of sweets. When he arrived his friends had full bags and
he looked at his bag that was rather meagre and burst into
tears. He threw it on the ground and walked out. And then
he didn't want the candy. I guess he understood it's not always
awesome doing the right thing. The injustice of it all. I can
still see his face of total distress and heartbreak. I kept the
bag with a couple of sweets in it. I placed it in a tin in the
kitchen. Every time I saw it, it broke my heart, so I just kept
it, for ten years, until it just melted into some sort of gelatine
goop sitting there in the plastic candy bag. It became a
running joke with me and my son. 'You still have that candy?'
he would ask me. One day I looked and the bag was empty.
Some ants ate it, I guess. I feel good when I see an ant in a
puddle of tears in my house, still digesting the saddest little
goop of candy on the planet.

I have this postcard that Dave McComb sent me in
1996 when he had his heart transplant. I played in a band
with him in the early nineties.

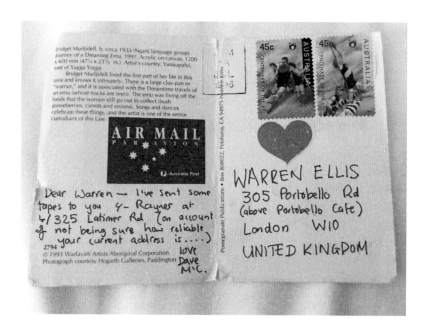

Dear Warren — I've sent some
tapes to you 4- Rayner at
4/325 Latimer Rd (on account
of not being sure how reliable
your current address is)

love
Dave
M·C.

WARREN ELLIS
305 Portobello Rd
(above Portobello Cafe)
London W10
UNITED KINGDOM

He was the lead singer in The Triffids, and Martyn P. Casey,
the bassist, would become the bassist in the Bad Seeds.
Dave had asked me to join his band after seeing Dirty Three
one night in 1991. I loved him. In 1992, the year the Adelaide
bikers made beige amphetamine and left indie rockers'
ankles rattling in their boots, I arrived at his house for a
first rehearsal. I'd been to a trash and treasure sale that
morning in an abandoned drive-in and the car boot of my
'67 HR Holden was full of stuff:

- a wooden birdcage
- ornate ceramic vases
- a big sign saying YES
- some Ugg boots
- velvet cushions
- a box of snow globes
- painted pine cones
- a hundred wooden coat hangers tied together
 with pantyhose

– a box of wooden cotton reels
– fourteen oil paintings tied together with stockings
– a box of keys
– a collection of Winnie the Pooh books

'Proof,' Dave said, 'the bikers had it right'.

The postcard has a big sticker of a red heart on the back of it. An ancient emoji from the last century. He wasn't totally sure I was in London but sent some cassettes to Latimer Road. When Dave passed away, 2 February 1999, it made me rethink my game-plan. Change my life. I couldn't face his funeral. I was totally fucked up on drugs and alcohol in Melbourne. I had been sleeping on my brother Murray's couch for a week. Unable to move except to pass out from drinking. He looked at me one day and just said, 'What the fuck are you doing?' I had no answer. This little guy who's watched over me most of my adult life.

I got on a plane loaded, continued drinking on the plane, continued from the airport to my apartment in Paris, decided if I arrived alive in Paris then I'd get clean and sober up. I realised that my lifestyle was adversely affecting the music I was making. Without this decision I would have had a very different creative output from 1999 onwards. I woke in Paris and started day one. I understood I needed to do this for me, and no one else. The same year I saw that concert of Nina Simone, and became custodian of the gum and I got married. It was the year I weighed up what was important to me. Throughout my entire life music seems to have continually been taking care of me. Watching over me. The card of David McComb's was in my Samsonite briefcase until 2001, then I transferred it to my suitcase when I retired the briefcase. I have had the postcard in every suitcase I've ever had that's toured with me. I finally left it in an archive in the Melbourne Arts Centre in 2019 when they proposed taking care of my artefacts. It was the first thing I offered them to start my collection. I knew I'd lose it one of these days.

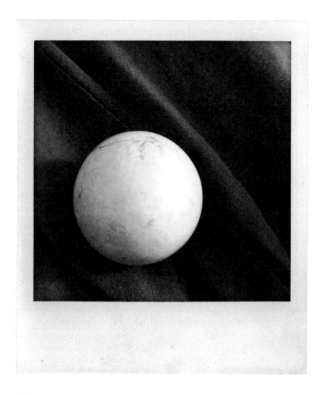

I have a marble made of marble that Arleta gave me in Athens in August 1999. I finally met her when I was there to play a concert with the Bad Seeds, and she invited me for coffee in her apartment in Attica. Arleta heard we had covered 'Mia Fora Thymamai' when Dirty Three opened for the Bad Seeds in Athens in 1995. When we played the song, the whole room started singing. We had no idea this would happen. Arleta wanted to meet me when I was next playing in Athens, and it was arranged. I had time between soundcheck and the concert to visit her. I took a cab to her apartment building and climbed the stairs. Fourth floor. It was humid and hot, one of those 35-degree days, and I was terribly nervous. I stood at

the door, knocked, and she opened the door. The door
opened directly to her living room. Her apartment was dark:
one table light lit the living room. The window shutters were
drawn and a fan whirred loudly. She invited me inside.
I walked in and sat down. She spoke lyrically and calmly to
me in a hushed voice. She asked how I had heard 'Mia Fora
Thymamai'. I told her a cassette of her second album had
helped me through a rough time in the late eighties. She told
me it was written by Giannis Spanos. She handed me her
nylon-string acoustic guitar she had played on those early
recordings. She told me about the composers of the piece and
a story about playing it with Leonard Cohen on Hydra in a
café in the sixties. She spoke of Greek philosophers and poets.
She pointed to a small round table with seven marbles on
it. They were different coloured tones of marble and varying
sizes. She said to me, 'Go to the table. Take each marble and
hold each one in your hand. Choose the one that feels right
for you.'

I chose one. Then she smiled and said, 'Please carry
it with you, Warren.'

There was a jar of Attiki honey on the table. As I
was drinking my coffee she picked up her guitar and started
strumming the opening chords of 'Mia Fora Thymamai'.
Then she sang it. I left as the sun set and went directly to the
concert with the marble in my trouser pocket. It has been in
my toiletries bag in a side pocket in my touring suitcase since
that day.

Every time I played Athens we would meet at her
apartment or at the concert venue after soundcheck.
I would get messages from friends in Athens or Crete saying
they had seen her and that she said to say hello. When she
became ill after a stroke, and unable to email or telephone,
people mysteriously contacted me to let me know how
she was. Arleta stayed in contact with me in some fashion
until she passed away on 8 August 2017. It's strange but I still
receive information about her, either from friends or unknown
sources. As if she is still reaching out to hold my hand. I found

a video from 2012 of her performing 'Mia Fora Thymamai'.
It made me think of Nina Simone's concert. Watching Arleta
struggle to get on stage then the audience rallying under her.
Feeling the power of song transform her.

19.

I have been on many stages and in many studios with Nick Cave for over a quarter of a century. I watched Nick fall off the stage in Iceland at the All Tomorrow's Parties Festival in June 2013 during 'Jubilee Street'. 'Look at me now,' and he turns around, throws the mic back on stage, takes a step, and falls two metres off the ramp down into a pit, and disappears. He just misstepped off this walkway he originally requested so he could get closer to the audience. He was gone so fast. The band kept playing faster and louder. It was the second song into the set. He got up and he instantly looked so diminished and wilted, like a pressed flower. He was obviously really wounded. He was helped up back to the stage by Ant and Barak, two guys on the crew, and finished the song. Then he walked over to me, placed his hand on my shoulder and spat out a whole bunch of blood, and I asked, 'Are you all right?'

And he replied, 'No.'

I asked him what he wanted to do.

'Keep playing,' he replied.

He sat down at the piano for 'Tupelo' and finished the whole show. A doctor was waiting in his dressing-room after the concert. He was X-rayed that evening in the emergency ward in Reykjavík. He had fractured four lower vertebrae. We played Glastonbury Festival the next day and finished the festival run.

I am looking at a photo of Nick from rehearsals for the *Skeleton Tree* tour, in Melbourne, day 3, 2017. It's from my point of view. Matt Crosbie is looking on doing the sound. Nick's arms are outstretched, I think it's 'Tupelo'. I took it because it was the first time I saw his old stage self in the rehearsals, his old self from before losing his son Arthur in 2015. I have watched him perform for over thirty-five years, in front, behind and next to him. And there he was.
The moment spiritual. Seemingly coming to his own rescue. I stopped playing and took the photo. Watching his transformation on the tour for *Skeleton Tree* then into recording *Ghosteen* and beyond remains a transcendence and transformation that continually astounds and humbles me.
A beautiful friend.

In July 2019 I took part in a series of four concerts with the Melbourne Symphony Orchestra at the Melbourne Hamer Hall in St Kilda Road, playing the soundtracks Nick and I had composed over the last fifteen years. It was a moment of realisation for us: these little ideas we'd been amassing over time were suddenly performed with a fifty-piece orchestra and a forty-piece choir. They were in somebody else's hands. It felt like a passing on of things. They had a new life. You create a piece of writing: a score, a film, a piece of art – it only exists once it's out in the world. These pieces had gone on to a new life beyond the screen and recorded soundtracks.

I wanted to mark these concerts with the Melbourne Symphony Orchestra performing our soundtracks by having my hands cast. I had seen several plaster-cast pairs in the Regent Theatre in Collins Street, Melbourne. I wandered in there while looking for a copy of William Blake's *America a Prophecy* in Kay Craddock Antiquarian Bookseller in Assembly Hall, 156 Collins Street. The casts were a way of marking the moment for myself, a musical life I never planned on. I contacted a Melbourne artist I know named Lisa Roet, and she suggested Mal, the caster in Heidelberg. I had my hands moulded using a pink dental product poured in the lower half of 1.5 litre Coca-Cola bottles.

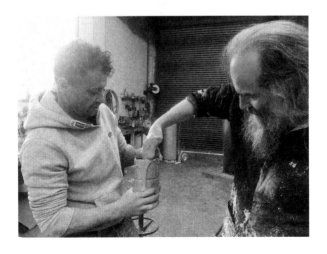

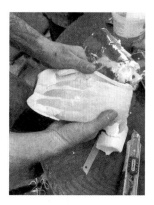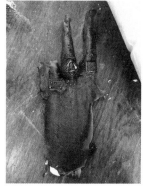

A wax copy and a resin copy were made. The process is completed using sand and a furnace and molten bronze. Old style. They were cast in bronze then I asked that they be silver-plated when I saw the images. There's something noble about silver. It was a beautiful process to watch unfold.

I had an idea to take them and throw them in the rubbish dump in Alfredton where I found the accordion in 1975. When I enquired, my father told me the dump was gone, a mini-golf course in its place. I decided to keep the hands as a pair of book-ends. It gave me the idea to do the same with Nina Simone's piece of gum. Have it cast in metal so if anything happened to the original I would have the trace of it in some form should it be misplaced or eaten by a Danish cleaner in the Black Diamond or stolen by that mermaid statue outside on the waterfront.

20.

Nina Simone's gum was something else. Like it wasn't mine. Its reach was seemingly bigger. I sensed this growing around the gum. This tiny object with a bigger story, gathering like a tornado. I was totally happy to lend it to Nick for the exhibition, but I was freaking at the thought it might be lost in the process. Not just for myself, but the fact I might let the gum down as custodian. This gum that wasn't mine, somehow it was the world's to share. I was also concerned if I lost it, then my luck in the studio would run out. By this stage I was convinced it was one of the reasons things had worked out as they had for me in my musical career. I decided that I had to create a replica of the gum in some fashion, to have some back-up if it was lost.

Finding the right people to work with. That's the thing, isn't it? How does that happen? What draws us to people? Or them to us? This trust that is needed for collaborations to exist. This beautiful fragile moment each creation has to pass.

I've always been grateful for the people I have been drawn to in my creative life. People who have brought out the best in me. Encouraged me to go as far as I could. But this idea to cast the gum was foreign terrain. And I was terrified at the thought of letting the gum go. I sent a text off to a friend of mine, David Noonan, who I've known since he was in short pants. He's a wonderful artist and beautiful guy from Ballarat who resides in east London. My younger brother's best friend in kindergarten. Ballarat is an old gold mining town in rural Victoria. There is a replica of the largest nugget ever found in the town, the *Welcome Nugget*, in the main street, Sturt Street, in front of some public toilets. I'd sit on my bike looking at it with wonder as a kid.

The Welcome Nugget is a large gold nugget, weighing 2,217 troy ounces 16 penny-weight (68.98 kg), that was discovered by a group of twenty-two Cornish miners at the Red Hill Mining Company site at Bakery Hill (near the present intersection of Mair and Humffray Street) in Ballarat, Victoria, Australia, on 9 June 1858. It was located in the roof of a tunnel 55 metres (180 feet) underground. Roughly shaped like a horse's head, it measured around 49cm (18in) long by 15cm (6in) wide and 15cm (6in) high, and had a roughly indented surface. Wikipedia

96

In my mind it looks a lot like Nina Simone's gum.

'I've got a piece of gum that I want to get cast.
It belonged to Nina Simone,' I texted. David was more than
curious and knew of its existence from *20,000 Days on Earth*.
And his reply was, 'Let me have a think about the right
person.'

A few days of thought later he came back and said he
had a friend, Hannah Upritchard. He thought she might be
perfect for it. 'I've told her what it is, but let me introduce you.'
And so I met Hannah, an east London-based New Zealander
and a jeweller. I contacted her and her reply was that she was
curious to cast it and had a few ideas on approaches. We set a
tentative date to meet up and for her to see the gum.

21.

I took the Tower Records bag with the gum and
towel inside from the drawer. I opened the towel and looked
at the gum. The first time it had left the house in twenty
years. I wondered what the fuck I was doing. I placed it in the
Samsonite briefcase and carried it to London on the Eurostar.
I was going over to do a session with Nick on a soundtrack
for Andrew Dominik's film *Blonde* at AIR Studios and I also
needed to clear out the lockup of all my instruments that
were hanging around. I hadn't looked in there for over twenty
years, and I'd been told it was full and needed purging.
By this stage I was on autopilot.

If I had thought about what I was doing with the
gum I would have stopped. I kept projecting disaster in my
mind when I thought about what might happen. Which I
often do. I went around to Hannah's house. It was pouring
rain and I was mostly drenched. I couldn't find her place,
so I decided to leave, call the whole thing off. Then I saw her
waving at the end of a cul-de-sac. She showed me into her
apartment. I performed a multitude of behaviours which
attempted to mask my anxiety. We chatted and stuff. Finally
I took the Tower Records bag from the briefcase. I opened
the towel and she looked at it. And kept looking. There was a
silence. More silence. Finally, she said, 'Well, we have to get
it off the towel.'

I was immediately reduced to a state of panic.
'Please be careful,' I said. I did have a plan B in my head
which consisted of cutting a circle of the towel around the
gum and letting them exhibit it on that, on a marble plinth.
But there were obvious problems with that. I would have
no copy. I would cut Nina Simone's towel. I reminded myself
of this before I suggested this to Hannah. Already aware
I looked foolish enough as it was, I could feel my ears pop

98

and the sound become muffled, that sensation when you put your head underwater and your heartbeat becomes an industrial pump. My cheeks a fish out of water. I was sort of hovering over her as if she was handling a newborn baby. Trying to be cool and totally not. I was instantly soaked in perspiration and I undid the fourth button on my best floral shirt. Three buttons is day time, four is for concerts. I really wasn't helping the moment so I sat down on the wooden kitchen bench and watched her. Hannah with this scalpel, being extraordinarily careful and professional, trying to prise it off the towel with me shaking inside and snapping a few photos to mark the moment. I decided to take some photos as a distraction, but also I wanted to document what was taking place. I sensed it was a moment. Nina's gum had stuck to the towel over the years. I had never tried to move it. I knew it was stuck because I had tried to tip the towel upside down at some stage and see the other side. I'd never even touched it with my fingers. Nina Simone's fingers were the last to touch it. Her mouth and teeth and tongue. Her spirit existed in the space between the gum and the towel. That concert was in the gum. That transcendence. That transformation. It took me some time to come to terms with the fact that this would be broken. Thomas Edison's last breath, on display at the Henry Ford Museum outside Detroit, is an invisible relic. Had I taken the stopper out?

22.

Cool as a cucumber, Hannah picked it up off the towel, between her thumb and pointer finger.

'There it is,' she said.

Her words were muffled in my blocked ears. She placed the piece of gum in the palm of her other hand. There it was.

'Do you want to hold it?'

I declined.

I'm not really sure how I felt. It was a mixture of feelings. I was happy it had come off and relieved it wasn't destroyed in the process. There was a sense of disbelief it was in her fingers. I was aware I'd stopped breathing and I was perspiring. She said it felt very solid, surprisingly solid, her words falling mutely on me as I was trying to take in what had just happened. I felt like wet cotton-bud, man. I understood the decision I had made but if I had thought it through I know I would have pulled the plug. Her husband was talking about a recipe for harissa and fondling a chipped, green enamelled garlic press he'd purchased in Italy in the eighties, which was his most treasured possession. The cup of black Earl Grey tea I had drunk was at the back of my throat. I was aware how wet I was from the rain, and that my shoes had leaked. I was wet from the inside and out. Hannah suggested that the next step was she wanted to take it around town and see if somebody could make a mould of it. That she would take it personally and would only proceed if she felt confident they wouldn't destroy it in the process. All I could say was, 'OK.' She looked at me, straight in the eye. 'You don't trust me, do you?'

And I said, 'It's not that, it's just kind of a big deal right now.'

She showed me moulds of a grandparent's tooth imprint she had turned into a ring, to assure me she had been trusted with precious things before.

'Warren,' she said. 'I get it. Don't worry, I get it.' Just like that.

And those words instantly put me at ease. I gathered my things and left. I left her with the Gum, the Tower Records bag and Nina Simone's towel. I didn't want to separate them at this stage. I felt weird about taking the towel without the gum. Fuck! What a moment. David Noonan had been right in his recommendation of Hannah for the task. But I had the strangest feeling walking out of her apartment, leaving the

gum with this person I had only just met. I was outside in the rain again. I decided to go back in and take it from Hannah, saying, 'Let's do it after the exhibition.' But then if it was lost, what would I do? I had set something in motion. It was off the towel. I stood in the doorway debating with myself. I became aware I was soaked with rain again. I turned away from the door and left. Again.

My uneasiness was apparent because about an hour later I received a photo from her of a small marmalade jar with 'Nina's Gum' written on it, placed inside her safe where she keeps all the precious stones she works with.

She texted me, repeating her words, 'Don't worry, Warren. I get it.' I felt largely better.

Those three words, 'I get it.' It's that moment when other people give you the confidence to trust and let go. Permission to let go. Often it is unspoken. It is understood telepathically. In the studio I've experienced this throughout my whole creative life, those moments when people reassured you with the confidence that allowed you to work to your greatest potential. Everyone getting it. To this day I haven't touched the gum. I haven't seen it physically since, except in the photo updates of its transformation. The beauty of others taking the baton.

23.

*It was a drizzling, grey day when Warren turned up.
He arrived with a piano accordion and an old violin as well as
his shabby briefcase and the roller luggage that he'd brought
with him from Paris. He was so familiar from all the pictures
I'd seen of him perform. Fine-boned, bright-eyed, thick eyebrows
and hair. Although it was cold his long black corduroy coat
and maroon shirt were open revealing a large silver chain
festooned with amulets and talismans. Warren was elegant in
his waistcoat and woollen trousers, leather shoes, everything
worn but beautiful quality. I lumped him and his possessions
damply through the front door and while I was making
tea he told me he hadn't seen these instruments in decades.
Did I want to see?*

*Warren knelt on the floor and opened them. He was
excited, curious – didn't quite know what to expect, what he
might find. It was joyful, carefree. 'Look at this hotel bill from
1996, I remember that ... My friend drew this ... Look!' He
had carved things into the back of the violin. 'See! ... I fixed
everything with tape in those days.'*

*It was fun, meeting Warren for the first time and
unexpectedly wandering into his history like this. He was eager
and alive and his stories were full of humour and love and
nostalgia.*

*I don't remember seeing the plastic bag when
he arrived. In my memory it just appeared. It was clearly old,
a kind of stiff, crunchy plastic with a quality about it that
made me think of Sports Direct. The moment he was holding
it his energy changed. It's not that he was less enthusiastic
or more muted – just suddenly he was more serious, more
grown up. A custodian of something big. It was as though he
knew that once he opened that bag everything would change.*

*His protectiveness was beautiful to see and it really
brought home the power of this little item. It felt like seeing a
vulnerability but also a pride. Owning this thing was a coup.*

It was a moment of genius to take it all those years back.

We sat down side by side on a bench seat at the kitchen table and Warren pulled a folded white towel out of the bag. I was surprised. I didn't expect it to be so white and so neat. I was expecting crumpled fabric and a make-up stain. This was clean and white and folded tidily. Warren smiled and the corners of his eyes lifted. He has strong but incredibly elegant hands and I turned to watch them as he gently opened up the towel to expose the gum.

I had expected it to be crushed … smudged into the fabric, formless. Thankfully it wasn't.

I used needle-point tweezers and a scalpel to detach the gum. Warren was sitting beside me and I felt glad I couldn't see him. The room was suddenly more still. It was like we weren't breathing, terrified of breaking the concentration and damaging the gum – disturbing the restful calm that came with this event. We were reverent. It was fun. It was exciting but I was also nervous. It wasn't just that I didn't want Warren to be worried that I was working slowly – it was that I could feel the effect that Warren had explained – here it is, this piece of history, this piece of Nina, imbued.

Hannah Upritchard
5 January 2020

24.

I became aware that the gum was bringing out the best in people. It's always been other people who have brought that potential out of me. I'm the inverse of the gum somehow. It's about connection. People who have encouraged me to be the best I can, allow me to go unrestrained. Letting ideas take flight. Letting me take flight. The wonder of playing in a band. Making music with people. I was watching something unfold in a visual way, that I sensed often as an abstract or internalised concept.

Hannah rode on her bike and took Nina's gum in the jar to several moulders in London, and none of them could guarantee that it wouldn't be destroyed in the process. They wanted to put a pin inside it to make a sprue. After auditioning these moulders, Hannah wrote to me that she was going to try it herself. She told me she trusted none of them not to destroy the gum. She said maybe we should make something provisory then after the exhibition we could make something definitive. The next day, I received photos of the gum and these little moulds made of Fimo with wax inside them. Hannah also sent a little video of her showing me the wax cast that she made, the actual piece of gum and the two halves of the mould. I thought they were beautiful. My concern for the gum vanished.

There were two obvious ways to approach this – make a silicone mould to make wax replicas or have it scanned in 3D and print it. But that didn't feel right – too impersonal and dismissive. It somehow reduced the gum into a single element from the many, many things that it was. I settled on something cruder but also more honest and human. I kneaded out a walnut of Super Sculpy. Warmed it to the temperature of my hands and rolled it into two squishy balls. Pressing the gum into the Super Sculpy I gingerly made an impression of each side and then tenderly, slowly eased it back out of the plastic dough. It looked amazing. The inverse in sharp relief looking back up at me from my desk. The first duplicate of Nina Simone's twenty-year-old chewing gum.

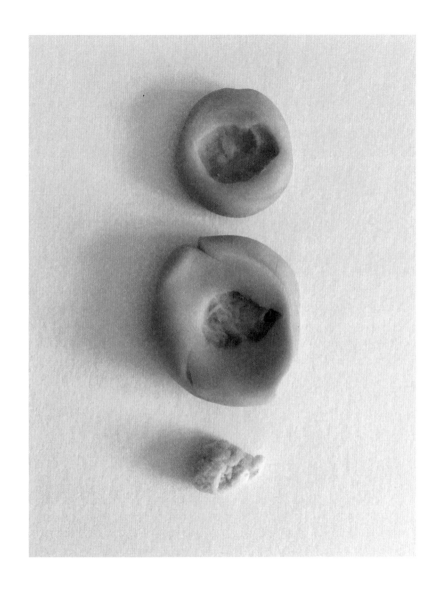

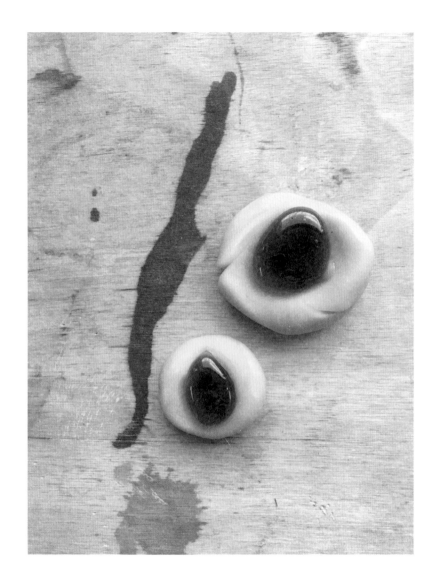

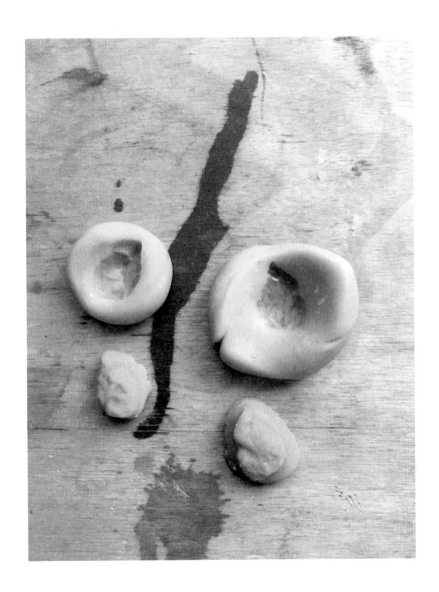

Pouring in the heated wax I wasn't sure what would come out. Waiting for the wax to cool was a kind of torture. I wanted to know. I wanted to meet it. To set my copy beside the original and know if it spoke the same language. It's not as if I hadn't done this before. So much of my work as a jeweller is to translate meaning into objects. To lift the ordinary and reframe it, to convey another person's sense or message. But this was somehow more.

Over the next few weeks Hannah refined the wax copy that she'd made and had it cast in silver. In case I wanted to reproduce the gum in a larger format in some other material – a sculpture or maybe a studio to work in – or to make bookends or a bean bag to sit in, Hannah took the gum to a scanner in east London. She filmed the process for me as well, always keeping me informed, every move. Keeping me involved in the process, and I guess to calm my nerves. By this stage I had total confidence in Hannah's custodianship of the gum.

I produced one copy originally – paring back the wax – connecting the edges and carving the details back in. Then a second. Two sides reconnected then cast in silver.
Each wax cast from our silicone mould needs to be refined. No two copies will ever be the same. I love that the copy still needs a craftsperson to concentrate, to understand, to sculpt, carving in divots and creases. I imbue my devotion and care into the object and through this process ensure that each one is its own. It feels like an opening, an invitation.
Duplicating the gum was an amazing process for me as a jeweller because it was somehow vast. It was an honour. I felt as though Warren was inviting me in – asking me to join him as a steward of a small but significant treasure. A closeted treasure.

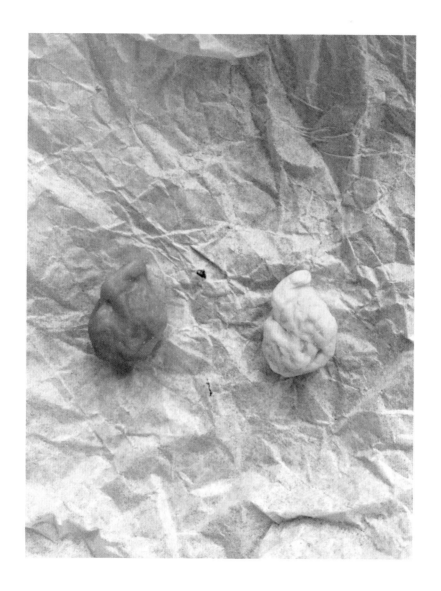

When I saw the first photo of the gum, moulds and wax copies I asked Hannah to take as many photos as she could. It felt like something beautiful was growing around the making of this replica. Some of her photos reminded me of Emily Dickinson's cut flowers in her famous *Herbarium*. In a letter from 1845, the 14-year-old Emily Dickinson asked her friend Abiah Root if she had started collecting flowers and plants for a herbarium: 'it would be such a treasure to you; 'most all the girls are making one.' As Richard Sewall points out, 'Take Emily's herbarium far enough, and you have *her*.' A facsimile of Emily Dickinson's *Herbarium* was published in 2006 by Belknap Press of Harvard University Press and I treasure a copy I have of this edition. I thought it might be nice to present a small booklet of photos of the casting process with a replica of the gum to friends.

I could see a process happening in front of me that was familiar. An idea coming to life. Like a song or piece of music. People rallying around to do what was best for the song. Holding it aloft. I became addicted to these updates, watching with joy as a new step would unfold. The metaphysical made physical.

117

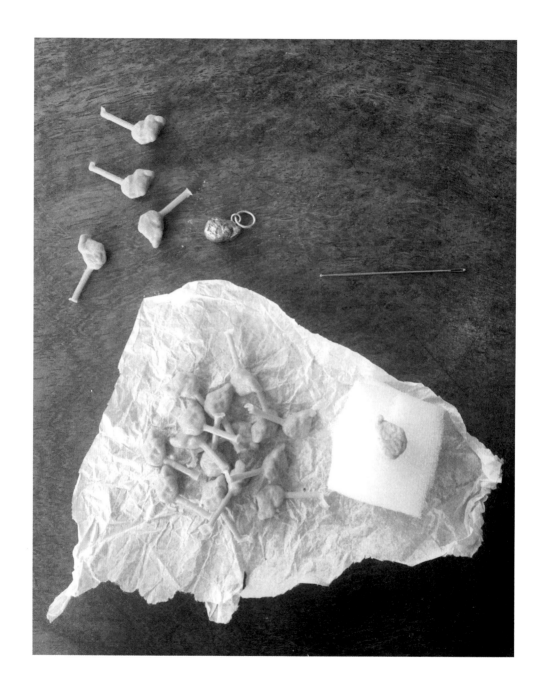

118

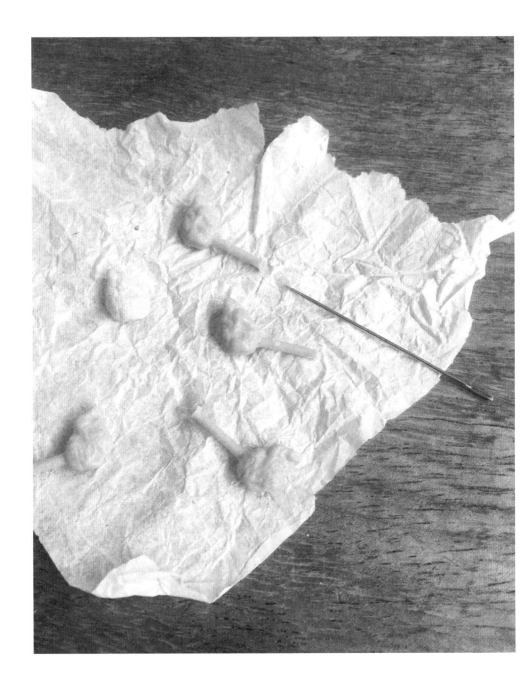

Pedicularis, canadensis, D.C.

Galium, asprellum, Sol.

Brasilia, latrorsa.

Fragaria, virginiana, R.Br.

Pycnanthemum, lanceolatum, D.C.

123

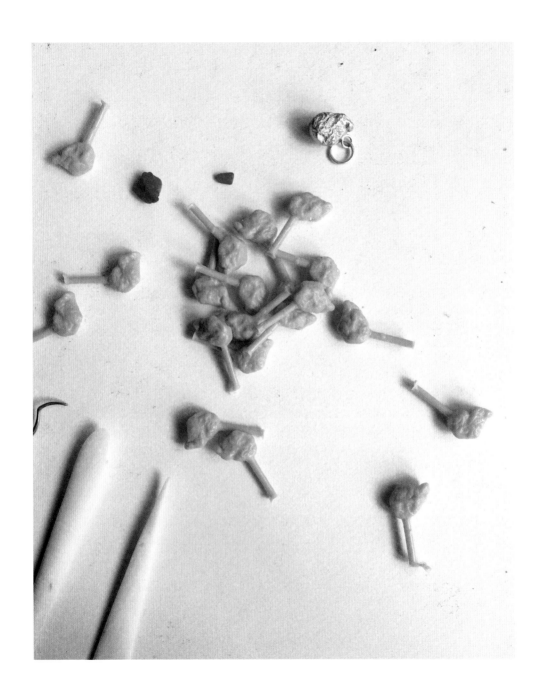

125

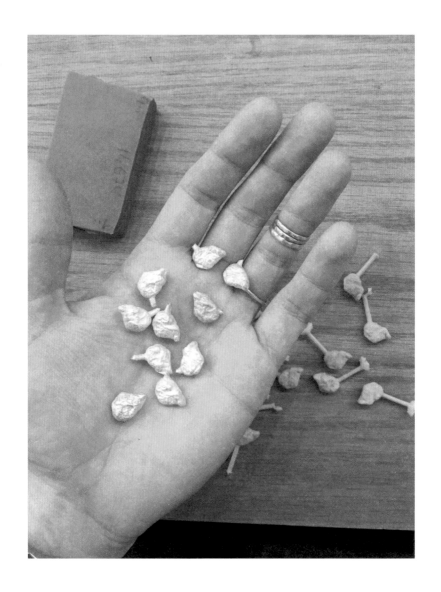

126

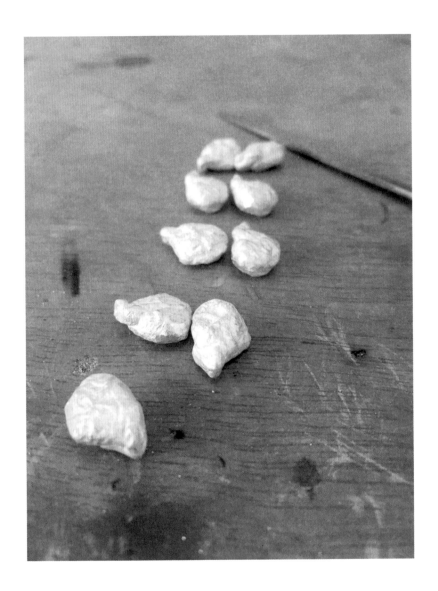

127

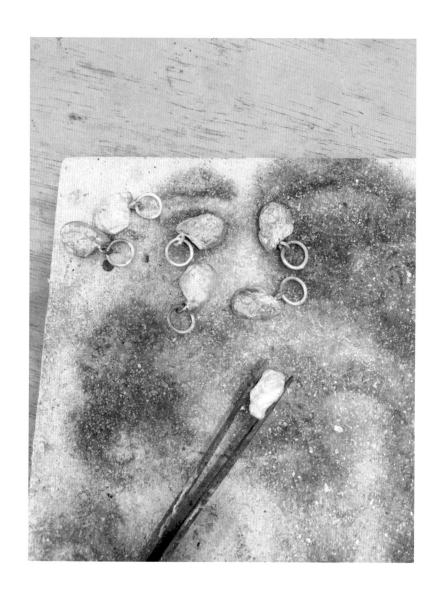

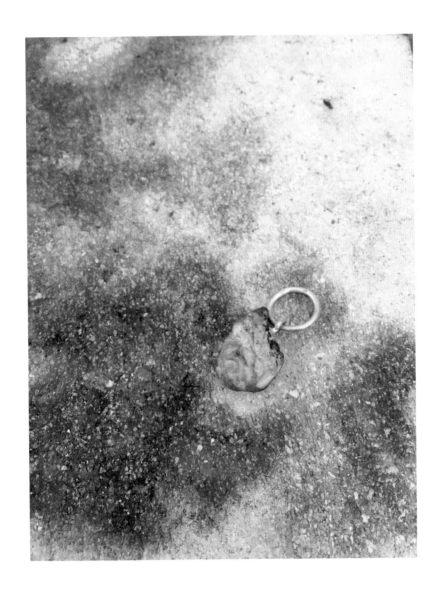

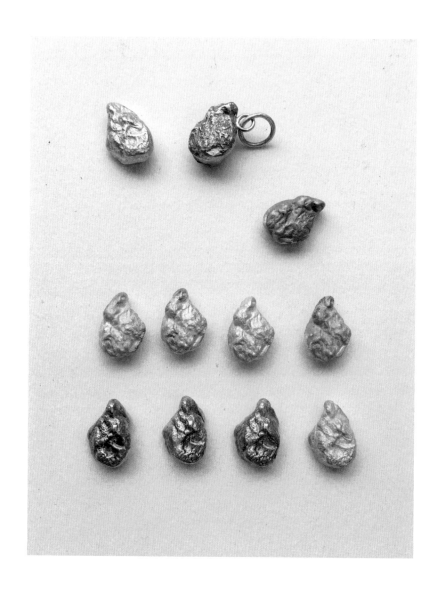

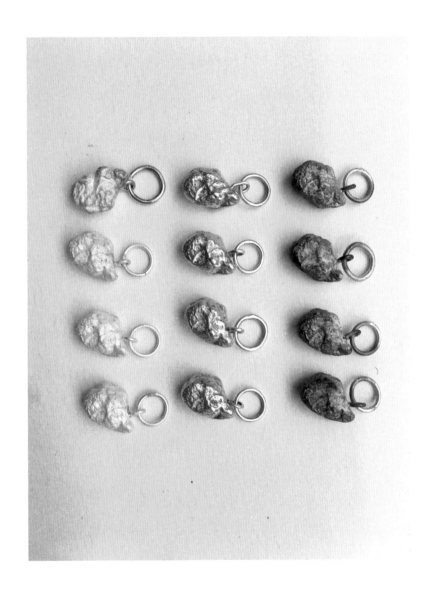

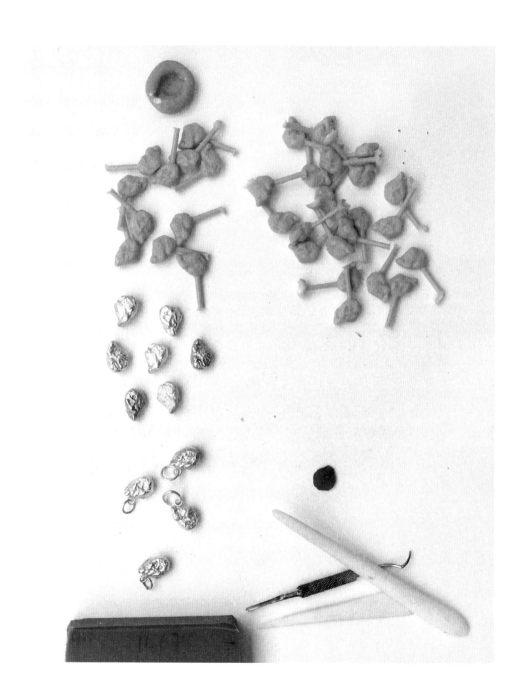

Campanula, speciminibus. Sol.

Linum salutis. G. l.

Cistus canalensis. 12. l.

Crepis tectorum. linearibus. 7.2.

135

I received these incredible 3D images of the gum that would allow me to make a piece ten stories high if I wanted to. One photo showed this little piece of gum sitting on top of this big scanning mat with everything whirling all around it, like an image from a Kubrick film. I could open the files and move the images around using the touch pad on my laptop. The first time I had touched the gum, so to speak. Why not build a monument 3 metres high? I'd live in a house the shape of Nina's gum. The gum was the relic laid in the foundations of a monument being built through love and care, with Nina Simone as the goddess over all.

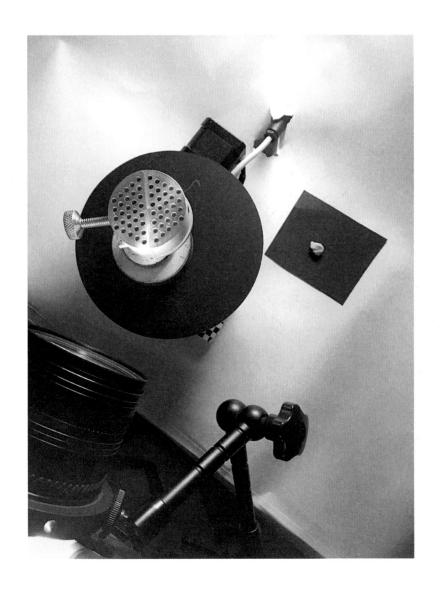

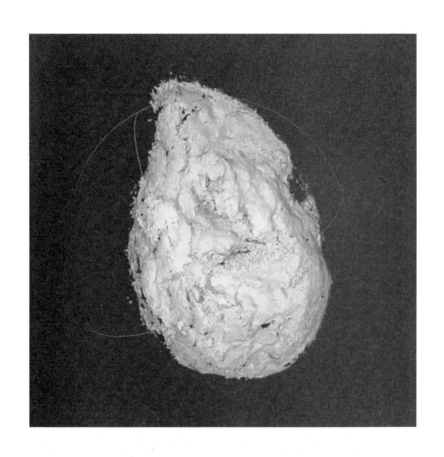

140

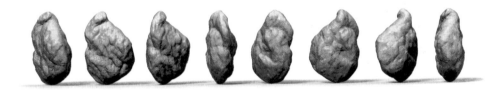

Hannah sent me an invoice from the scanning
company, with the added note to the invoice, 'We wish you
continued success with this extraordinary project. If you
ever come up with something as bizarre as this, please come
to us again. It will take a lot to top this.'

25.

I sent a picture of the gum and moulds to Ann
Demeulemeester, the Belgian fashion designer. We met in
the late nineties after a Bad Seeds concert and we have kept
communication since then. She told me she had used several
of Nick's and my music and film compositions for her fashion
shows in Paris over the years. On one occasion I composed
some music for her fashion show in 2008, and she had gifted
me a ring made of a moulded silver pigeon's claw she'd found
under a tree in her garden.

Ann told me she had shaped the foot around her
finger and then had it cast by a craftsman in Munich. And that
really stayed with me, the beautiful connection between
nature and design. The beautiful, creative simplicity of design.
Ann cares deeply about the creative process and the spiritual
realm. I've always been inspired by her dedication to her work.
She has a way of articulating concepts that are abstract to
me in a very poetic and human way. She believes in the power
of music and draws energy and inspiration from it. I knew that
images of the process we were undergoing with the gum would
be something Ann would respond to aesthetically. I knew
she would get it. I sent the photo of the mould and replica and
explained the backstory. It was raining and I was in Paris

walking and texting along the River Seine near Bastille, looking for bathroom taps, when I received her text. I stopped in the rain.

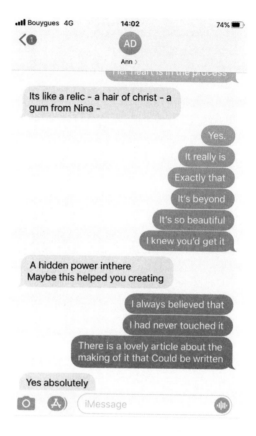

It took my breath away. I stood there smiling and replying to her texts, drenched to the bone, looking at the text. The thought of a hair of Christ. Almost invisible, fragile. I could hear the cars honking their horns at Place de la Bastille. I walked straight past the shop selling taps and took the metro home.

Nick had first mentioned 'Pure Religion' in a text we had about items I wanted to contribute to his exhibition. Ann put the word 'relic' again in my mind, an artefact,

144

this little object carried devotionally and transformed to make something greater, or make the awareness of it greater. I told her the story. I sent her more photos, and then the conversation went to these feelings I was having, how you need to find the right people to carry these precious objects into the world. That somehow the gum was attracting these people.

I wanted to gift Ann one of the silver ingots. Ann texted the next day. She wanted to make something with the cast. A pin or a brooch she suggested. She wanted raw silver casts and some wax casts with the sprue still attached. I asked Hannah to send them.

26.

November 2019

Nick called me and brought to my attention that
Christina Back, the head of exhibitions, was 'concerned about
showing the "actual" gum at the exhibit'. He had explained
what it meant to me and she was concerned if the gum
was out of my reach for a period of time, would I be OK?
If the exhibition toured I would be without it for potentially
four years. She would prefer to have a copy of the gum in wax
painted white to be displayed in the exhibition. There was
never any question in my mind that they shouldn't have the
original.

5 December 2019

When the first two silver ingots were complete
I went to Hannah's studio in the backyard of her house.
I kept one, she kept the other. Mine is the first cast she made.
It is misshapen and shows her struggle in her first attempts.

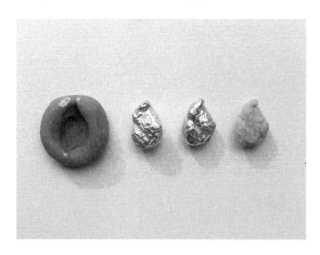

It reminds me of the beauty in rough mixes in the demo stages of albums. I decided I needed twenty of them, one for each year that I'd had the gum in my custody. I wanted to give them to people who had been really integral to my development as a musician, as a person; people who had really encouraged me, to bring the best out in me. I asked Hannah to make the number I required and to send David Noonan one ingot from the twenty I requested. She gave me the ingot in a plastic container for dressings from Burger King. She told me she liked giving rubbish a second chance as packaging for the pieces she created. Hannah continued to send images with her tools and the process as she worked on the replicas. The silver shavings from removing the sprue on each cast. Arrangements of the gum with the copies. She sent videos of the process. Images of a multitude of silver casts in various finishes. Should they be soaked in pickle juice? Polished? Raw finish?

I decided on several finishes. I wanted a silver hoop attached so it could be worn as a pendant. I wanted some without attaching hoops to put in velvet boxes like a precious stone.

I wanted to share the gum.

22 December 2019

I took the Eurostar to London. I was continuing work with Nick in London, in AIR Studios, on the sound installations for his Stranger Than Kindness exhibition. Each room needed a different ambience and the aim of the music was to make the viewer's experience immersive, beyond visual. Hannah met me in east London. It was raining. She gave me a little wooden box stamped with an image of Mozart and these words stamped in black:

<div align="center">

MOZART-TORTE
Spezialität aus Österreich
Groissböck

</div>

I opened the brass clasp and wasn't prepared for the contents.

There was a scrunched piece of orange crepe paper acting as packing to protect the contents. I removed it. Inside was a trove of individual white paper packages tied with plain string, paper tickets labelled in biro noting the contents.

'Silver Gum, Moulds, Plain Gold Gum, Plain Silver Gum, Gum with rings.'

I was overwhelmed by Hannah's care, and the contents. This journey in a box.

Inside the box was:

— one half of the original mould. The other half broke
— twenty-two silver gums with loops
— a gold gum
— four silver gums without loops

One package had a note: 'Don't open this one until Christmas.' So I waited.

25 December 2019

Inside was the most wonderful little red seed pod with a handmade metal cover sealed closed with crimson wax, the colour of bottlebrush. Inside the pod was a white gold ingot of the gum. I texted her that it was beautiful. She said she found the pod in Argentina quite a few years ago on the beach. She'd just been waiting for the right time to use it, and this was the right time.

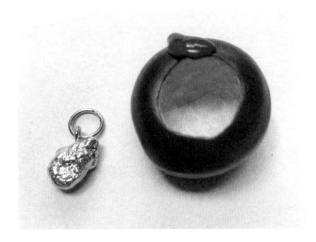

Hannah gave me the box and told me she was leaving for New Zealand to donate a kidney to her mother. It struck me as strange because the gum reminded me of a kidney, or a heart. She'd been labouring over this little item for months, and the next thing she does is donate a kidney. Hannah sent me a photo of herself post-operation with a new incision painted yellow in Betadine. She had her piece of gum around her neck in a hospital gown, in the hospital bed.

27.

January 2020

When the replicas were finished, the gum itself had
to be collected from Hannah and taken to ATC Management,
the office that takes care of Nick Cave and the Bad Seeds,
so it could be transferred to the Black Diamond in Denmark
for Nick's exhibition. Hannah needed the original to reference
in order to shape each ingot.

Suzi Goodrich contacted me to arrange collection
with a courier. She wrote asking if it was a piece of gum that
was being collected in a small marmalade jar with acid-proof
paper? I explained it was, and that it was Nina Simone's
gum.

She wasn't aware that it was hers and the tone of
the exchange changed instantly. She said that she didn't
trust a courier to collect it. She didn't trust anyone. She said
she couldn't bear if it was lost or something happened to it.
She had to collect it herself.

Suzi met Hannah at her workshop, collected the
jar with the gum and took it into the office. But she didn't
want to leave it in there at the end of the day, so she took
it home. She wanted to know where it was at all times.
This incredible care, concern and love for this object just
kept multiplying, kept expanding, was contagious. And even
before people had actually seen it or were in charge of it.
The story of the gum was enough to ignite this care and
concern. I was in LA working on a soundtrack when Suzi
texted me to say the gum was in her possession. It reminded
me of the care needed in the studio when an idea is presented,
that the wrong words can deflate someone's attempts. That
we can easily kill an idea. That fragile moment when it is
presented. The permission to proceed given by the confidence
of others. That feeling of entering the studio, wondering if
this is the day it all stops.

Rachel Willis and Molly Cairns from the Bad Seeds' management office arranged a seat on the plane for my violin with the gum inside the case.

Rachel sent me images from Gatwick Airport to reassure me it was in safe hands: Molly keeping watch in the plane seated next to it.

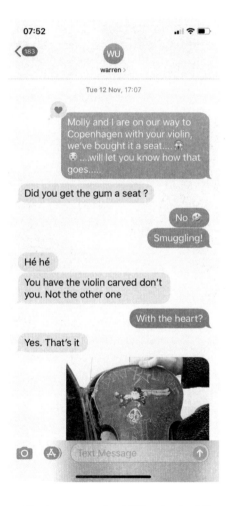

It dawned on me that my musical life started from someone's trash. An accordion I had found at a rubbish dump became

my link to a lifetime of music. The gum being inside the violin case was some kind of serendipity. That this gum, a piece of trash to others, was united with my lost fiddle from near the beginning of my journey that started in a rubbish dump. The violin that came to my rescue. A violin I had thought for twenty years had become a piece of trash. The gum that watched over all my creative journeys since 1999. They sent me photos of the gum in the case. Every step of the way they took care to assure me the handover was being done with care.

It arrived safely in Copenhagen, and was handed over to the Black Diamond staff. I was sent photos of the handover to Christina Back with Molly and Rachel watching on.

It was placed in a safe in the library's archives. This transferral of care. Doing what I would have done if I had been there. Things on my behalf. Somehow the text format of communication made it all the more intimate. Updates in real time. Not once did I ever ask anyone to inform me or send an image. I was floored by the depth of care. People following their best intentions.

Christina told me Rachel called her several days after the delivery to check if the gum was safe. She panicked and went to the safe and opened the violin case to see if it was still in the marmalade jar. It was. She told me from that day on she has felt nervous about having it in her possession.

The beautiful thought remains with me, that the big story of this gum is entirely projected by people. Their compassion. It is within them, springing from the purest of places. The imagination. The divine. The human heart. Everything and nothing.

A conversation evolved around insuring Nina Simone's gum and my violin. The library's insurance brokers wanted to assess the chewing gum's market value and put a number to it. I had no idea.

With the assistance of the curator of the Melbourne Arts Centre, Janine Barrand, it was agreed that it was a priceless and irreplaceable object, but would be attributed the value of a thousand Australian dollars. I received a form to sign off on allowing its use in the exhibition.

Chewing gum value

Hi Warren

On the subject of insurance, we also need to get the chewing gum insured!

It's very hard to put a value on something like that, of course. The exhibition curator said the best way to think about it was what would someone have to offer you for you to sell it (although i don't think you'd sell it for any money!!)

Thanks
Suzi

Exhibition items

Hi Warren

I've spoken to Janine at the Arts Centre Melbourne, who has proposed the below valuations (althought she accepts that the violin and chewing gum are actually priceless, so valuation is very difficult.

Can you let me know if you are happy with this, or if you prefer a higher insurance valuation?

AUD $10,000 - Violin
AUD $1,000 - Chewing gum

Attached is the loan agreement for these items, are you able to print and sign, or should i sign on your behalf?

Thanks
Suzi

28.

I took the plane to Copenhagen from Paris for two days to install the soundscapes for the exhibition Stranger Than Kindness. Before I left Paris I wrote to the head of exhibitions, Christina Back, to let her know I was coming and that I wanted to take some photos of the gum in its safety box. I was enjoying following the path of the gum in images and the story just seemed to get greater each turn it took. I'd been told by Nick in January that it was going to be exhibited behind bulletproof glass with lights directed on it and a burglar alarm underneath the hand-stitched cushion that Christina was going to make. But I also wanted to see the actual thing again. But the reply was, 'No, I'm sorry, you can't see the gum. We need forty-eight hours to get clearance from security. It's in a safe, I'm afraid. You can't photograph it or even look at it.'

It was an extraordinary moment, because finally I understood the gum really was out of my hands. I couldn't access it. It wasn't mine any more. It felt wonderful. That same feeling was familiar to me. When you make an album there is a period where you have finished and it's a secret and for that time it doesn't exist beyond a few close people. You know that when it is released there is no going back. With albums it seems you have to fall in love with them at some stage in order to know the work is done, to let them go. Then they're gone. It's OK to leave. But this period in between is quite extraordinary. This kind of beautiful limbo. I was seeing this happen in a very physical way with the gum. A concept made flesh.

18 February 2020

I flew once again from Paris to Copenhagen. I arrived at the Black Diamond library with Rachel while the exhibition was being prepared. Nick was overseeing the whole process. Unfinished, the exhibition was already mind-blowing. Such a generous and loving work. Vast. Christina later told me Nick had asked her to wait until he arrived so he could choose the colour of the velvet for the cabinet and the placement of the marble plinth and the lights for the gum. She had sent him 3D manipulations but he wasn't satisfied and wanted to be present to make decisions on the interior and placement of the gum in its display cabinet. I walked around the exhibition with Nick and Christina and we came to the empty box for the gum. There were several swatches of velvet cloth samples, light fixtures. An unconnected alarm, staple gun. Nick was holding a light above the plinth suggesting the angle and the placement and potentially what colour material for the lining of the cabinet. The plinth was there amongst the trimmings with a piece of gum on it.

'That's Nick's gum,' said Christina. I guess my alarm was visible.

Nick picked it up and squashed it between his thumb and first finger, 'Yeah it's only mine, don't worry, Woz.'

GENERAL CONSTRUCTION
- The showcase constructed by 12mm plywood.
- H 77.2cm × W 57.2cm × D 58.5cm.
- In front of showcase an oak frame.
- H 80cm × W 60cm with 3mm glass.
- Inner of the showcase upholstered with golden velvet.
- Light source: Gizmo zoom spot, 2,700K.
- Gum placed on marble pedestal.

PRESERVATION
- The showcase is lined with boards of polyethylene to ensure any degassing from the plywood construction of the showcase.
- Edges are taped with the frame-sealing tape 'Copper Corrosion Intercept' a polyethylene embedded with a copper layer to prevent migration of acids, corrosive gases; and resists mold and mildew.
- The material of the gum is likely to be a synthetic rubber which may deteriorate by light/UV, high temperature, high humidity, oxygen and pollutant gases. It may become brittle, crack and turn yellow through intensive light exposure.
- Based on this the showcase is set to have a consistent and monitored climate: Temperature: 16°–24° (max. fluctuation within 24 hours: 4°) Relative humidity: 45%–55% (max. fluctuation within 24 hours: 5%) Light exposure set at 100 lux.

MAINTENANCE
- The gum is checked on a regular basis to monitor any change in texture.

SECURITY
- Wireless shock alarm. (Reacts on any shaking of the showcase.)
- Wireless distance alarm. (Reacts on any change of distance between frame and back plate of the showcase, i.e. silent removal of frame.)
- Video monitoring of the exhibition space 24/7.

158

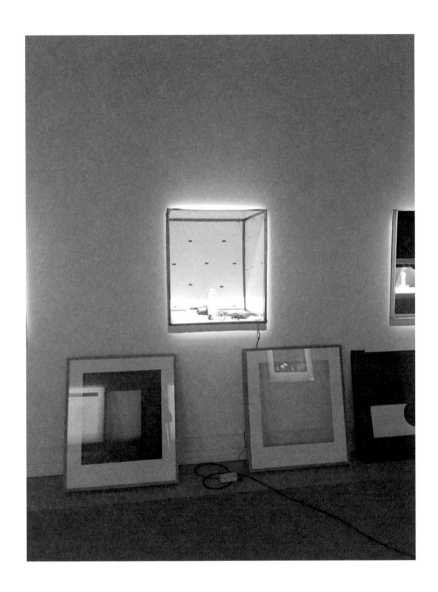

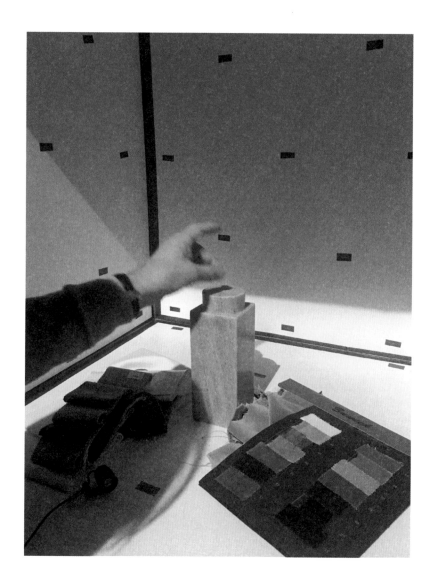

160

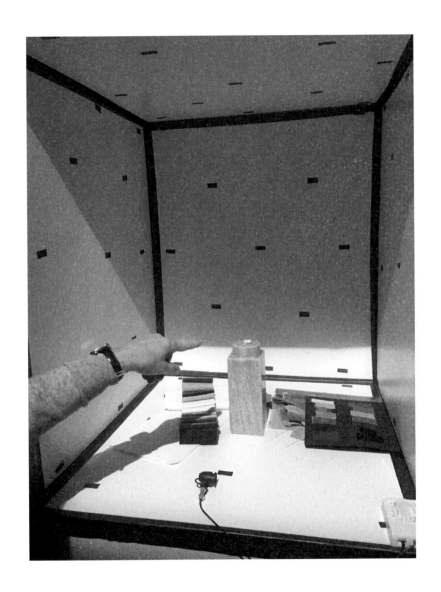

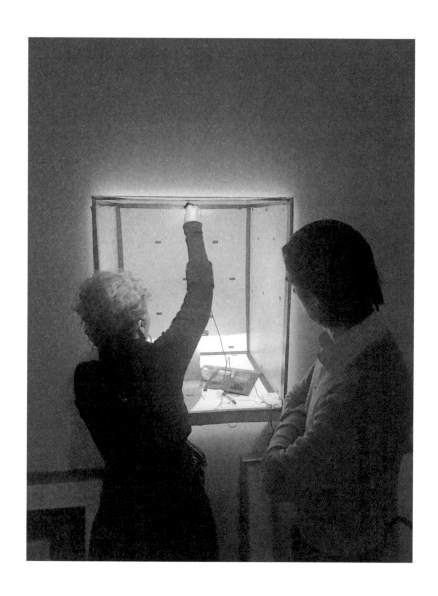

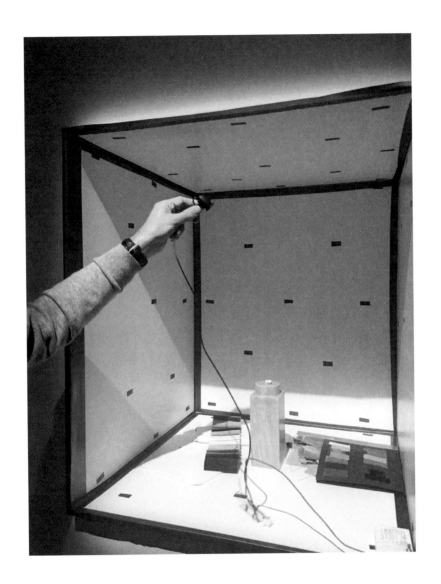

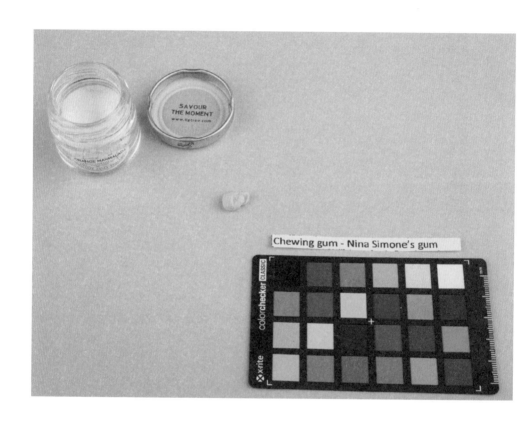

Chewing gum - Nina Simone's gum

Nina Simone's chewing gum is a lovely example of
how things can carry a meaning much larger than the thing
itself. It's a small fragile item that holds the greatest story.
The encounter with an artefact is one of the most sensitive
and powerful moments of an exhibition visit. As an exhibition
designer I have always been curious about the potential
of the spatial interpretive exhibition design. And how the
embodied and multi-sensory exhibition encounter can change
the visitor's experience of an object on display into a deeply
personal and poetic understanding. But I also know that in
the end the experience of an artefact is most of all shaped by
what we ourselves are bringing into the space. The stories that
we project onto the object make it glow and become of great
importance. Suddenly it's not just a gum. It's Nina Simone's
gum. That holds all the stories, all the suffering and all the
glory of her amazing life and work as an artist. Having lived
with the gum for more than eight months now I often find
myself filled with awe. Both wonder and concern. Overwhelmed
by the big responsibility of taking care of this little thing.

One time Rachel wrote me out of the blue to ask if I
knew where the gum was. Her sudden concern made her reach
out. I assured her that gum was safe in the security box of
the museum. But a feeling of unease grew in me and I had to
drive to the museum, enter the security box, unlock the violin
case, open the little jar and remove all the small tissue layers
to look at the gum with my own eyes. And even then I was
almost not sure it was there. The same thing happens every
time I enter the exhibition space where the gum is exhibited.
My heart stops for a bit until I'm assured it's safe and sitting
on its pedestal. If the exhibition ever goes on tour I have to
get a replica made. Otherwise I'll have no rest.

Christina Back
Head of Exhibitions, Royal Danish Library
Copenhagen, May 2020

29.

10 February 2020

I had my silver ingot around my neck and I was in a
café showing a friend, Julien Mignot. The waitress asked me
what it was. When I told her it was a cast of Nina Simone's
chewing gum she welled up in tears.
'Can I touch it?'
Dan Papps from Faber had asked me in 2018 if I'd ever
thought to write a memoir. He had seen my improvised rants
mid-song at Dirty Three concerts. He said I was a funny guy
with maybe something to say. I told him I couldn't think of
anything more tedious than a memoir. He said if I had another
idea for a book he was always interested and to give him a call.
In December 2019 I was in Paris working on some music for
a documentary titled *This Train I Ride*, which follows women
who train hop across America. I was looking at the images
of the gum casts and I called him. I said I had an idea for a
photo book about a piece of gum, and explained the full story.
He shouted it around the office. He told me everyone smiled
and looked curious. He said to come into the office next time
I was in London for a chat.
In late February I did my first ever pitch, to Faber,
around a large table for this book idea I had about Nina
Simone's gum. Dan Papps and Alexa von Hirschberg, Rachel
Willis and Jack Murphy sat around the table. I told the story
of the concert and taking the gum. The decision to make
a copy before handing it over to the Black Diamond for the
exhibition and some of the images of the gum's journey. I had
the box of casts with me and placed it in the centre of the table
after telling the story. When I opened the Mozart box in the
centre of the table with the casts, the atmosphere in the room
shifted, everyone leaned in, like in an amphitheatre. Alexa's
eyes welled up, and her voice changed. 'Dear me, I'm suddenly
very moved. Is that it? Can I touch it?'

After the pitch I had a meeting with FKA Twigs about working on a project together. I was running late. I told her where I had been and why I was late, explaining the idea for this book. I showed her the silver gum around my neck. She looked at me with disbelief. I offered the ingot to her. She raised both palms in the air towards me and took two steps back.

'I don't even want to touch it.'

Nick told me how strange it was to be reprimanded at the gallery for touching his own property in the exhibition, that his possessions had crossed over somewhere, out of his control. There were people with gloves on hand every time he went to grab his stuff. Christina told me his piece of gum is in the safe now in the Black Diamond, when the switch was made for Nina Simone's. Nick and I were in the studio working on a soundtrack for Andrew Dominik's film *Blonde*, talking about 'great pieces of chewing gum' as a concept for an exhibition.

'What would be the greatest piece of gum to have in such an exhibition?'

I suggested Bowie's might be great.

'But he would want Nina Simone's. Everyone would,' countered Nick.

Then Covid-19 happened. The March date for the exhibition opening was cancelled. The exhibition was under plastic until 8 June. Christina kept sending me updates of the installation. When the box was prepared the gum was fetched. On 5 June 2020 the placement, by conservator Birgit Vinther Hansen, occurred. Watching it all by remote was so moving. Much of the transmission around this project has been remote, rich with the intimacy that reading a text can highlight. The images of the gloved hand placing it on the plinth. The lights focused and the box sealed. Seeing its place in Nick's Hall of Gratitude. The lights illuminated. The room empty. The box sealed at 20 degrees Celsius. The gum looking monolith-like in a setting sun.

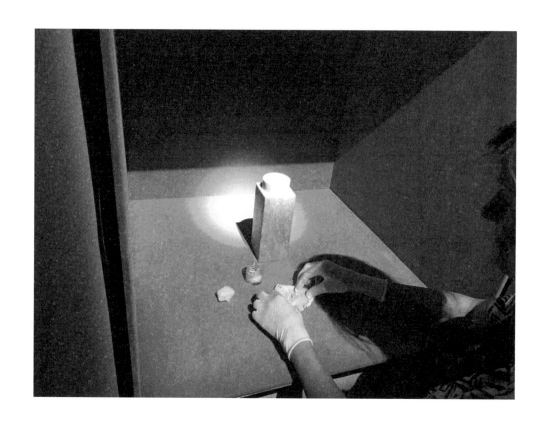

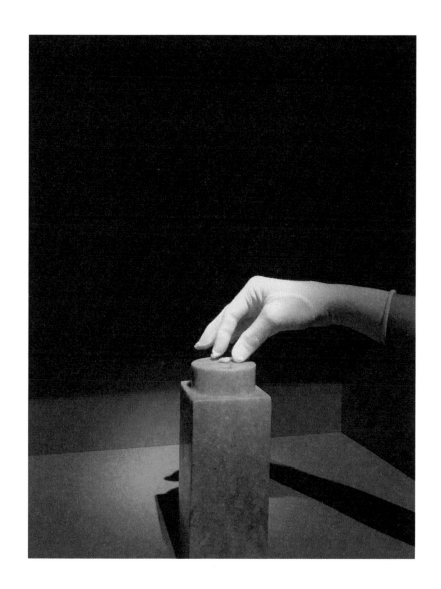

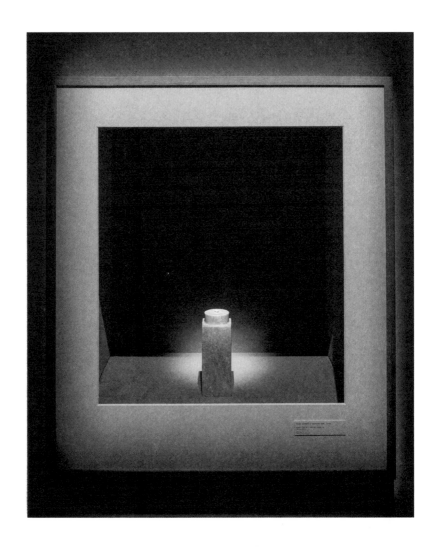

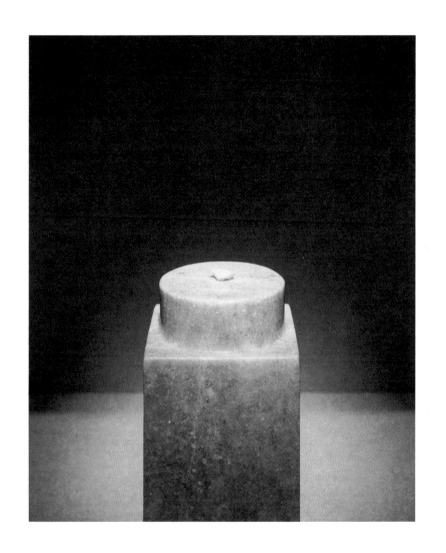

30.

I needed to write this book. The images I had been collating were the narrative. Dan and Alexa at Faber suggested I needed a text to accompany the images. I wasn't so sure. Nick had offered to write an introduction when I told him about the idea of a book about the gum. I imagined his intro and the images would suffice. I could add a few pages about my part in the story. It seemed to me totally obvious what was going on from the images. But that's because I was in the story and I needed no guidance with the images. I also couldn't see myself in the story. Several people had said to me that they found it incredible that I had actually thought to take it. I had never questioned my actions. For me, it had always been about the gum. I panicked at the thought of this new terrain. I hadn't written anything beyond emails since 1985, when I was studying, handing in essays about books I had hardly read.

In February 2020, on the plane back from Istanbul to Paris, I started jotting things down in a notebook from the Museum of Innocence. I tried to transfer it to the computer. The blank page was paralysing. Every time I attempted to start I became anxious. I could fill a Pro Tools session with music of varying quality, no problem, but this was another thing. I could more or less tell a story in conversation, but this seemed different. In conversation you can answer queries and the listener plucks what they want from the words hanging in the air. In the way music communicates when we listen. Instrumental music allows you to draw your own emotions, put yourself in the narrative of the chords and melody. Take what you want. Create your own relation to the vibrating narrative. Pure emotion. The written word seemed such a commitment, concrete. I just didn't know where to start. The more I thought about it, the blanker the page became.

I had intended to write this on tour, the *Ghosteen* European tour in April 2020, but that wasn't happening due to the Coronavirus lockdown. And this writing wasn't happening due to my own internal lockdown. I mostly found fear productive in the studio; it wasn't the case with writing. So I decided to seek help from my friend Oren Moverman. He's a wonderful scriptwriter and director I have known since 1995. He resides in New York City. We met after a Dirty Three concert and he gave me a copy of *Jesus' Son* by Denis Johnson because he was working on the script for the film adaptation. Noah Taylor had suggested he come and check out the band when we played in New York City and he never could shake me. We touched base each time I passed through New York or Los Angeles for a concert. We had reconnected in April 2020 when our mutual friend, dear Hal Willner, passed away from Coronavirus. During the phone call I realised Oren would be perfect to help me with the text side of the book. We conducted seven long interviews over Zoom. He asked me to tell the story, then asked questions that pushed me to go places I hadn't thought were connected to this. Where did I grow up? When did I start playing music? When did I meet Nick Cave? Why did I choose the violin? I was reluctant, as I thought this story of the gum wasn't about me. I couldn't see the story from the outside. I had never thought about why I acted as I did. I thought the story was from the moment I took the gum, taking care of it, having it cast and exhibited. The gum's transformation.

I sensed that as soon as I had told him the story I had been keeping in my head, it made room for other thoughts to come in. Associations. A purging of sorts. Once the idea was out it made room for more ideas. Oren transcribed the interviews and sent me a draft. I realised the obvious isn't always obvious. I had to sit down and write this as only I knew the deeper story that Oren was pushing me to tell. I sat with the draft and started writing around it, filling it in, cutting it out, moving it around. Looking at the shape he had presented. The threads of the story. Oren helped me find

174

my way in, always encouraging me in my efforts. He helped me make that leap. Without him the page would be still blank. 'You've got this, Warren,' he kept texting. I realised that each time I spoke with a friend about this story I was trying to write they helped me see the way in. I spoke to adults and teenagers about it. I would watch their faces change as they got the idea. I communicated with the journalist Suzanne Moore. When I told her about this book idea, the next day I received a thousand-word email that concluded:

... If this is all barking up wrong tree then, cool,
I don't mind at all and you start refining your ideas in your own
words. I am, as the shrinks say, merely reflecting back to you
what I am hearing.
Love, Suzanne

Suzanne was generous and encouraging. We discussed her helping me write it, before Covid happened. She helped me before I had even jotted anything down. Putting ideas in my head, confirming what I thought was true. Sending me things to think about, things like Thomas Edison's last breath. She sent me poems. Asked me questions. She compared the process of writing to plucking sounds from the air and following instinct to construct a piece. 'All lines radiate from the gum. It is the heart of the story.' She told me to think about it like a piece of music I was trying to form from its beginnings. She told me to 'listen to the gum'. I could hear the story free in the air when I spoke about it. At some stage I became aware the gum was writing this story. Directing the narrative. All I had to do was listen and observe. Have faith in the process. Nick told me he always has a sense of anxiety approaching lyrics when starting work on each album. I took some consolation in these words. I told Nick I was having trouble as my page in Text Edit was blank and overwhelming.

'What the fuck is Text Edit?'

'It's some application from the nineties I have on my computer.'

'Never heard of it. I use Word,' Nick replied.

I opened Pages for the first time.

I always figured the story finished at placement of the gum in the exhibition, but the gum wasn't letting that happen. It kept finding the desire to do well in people, attracting this growing pool of love and care. It will continue to lead the story beyond this book. The more people become involved, the more the story grows. I became aware of the circular narratives within the story, closing like rings. Infinite. Eternal. This book is a beginning. We are watching the opening credits roll.

Coincidentally, I started working on this at the same time as a project with Marianne Faithfull. She had recorded some spoken word Romantic poems by Keats, Shelley, Byron and Wordsworth before her hospitalization from Covid-19. She wanted me to put music to them. Both projects seemed to become entwined. How to work remotely in a new terrain? I would put on the texts she had read, then try to write this text. Then I would open a Pro Tools session and compose some music for a poem, and listen to the music on a continuous loop as I continued to write, working on narratives that involved travel when the world had ground to a halt. I sent Nick the poems and he loved them and wanted to add piano. He went in the studio for a day in Ovingdean. Isolation and working remotely made the trust in the collaborative process even more heightened and apparent. I handed my first draft in the day we finished the mixes, and the same day I finished all eighty-six episodes of *The Sopranos*.

Ann Demeulemeester eventually received the casts of the gum. Due to Hannah being in New Zealand donating a kidney and the lockdown caused by Covid-19, she received them in May 2020. When the mail arrived during the lockdown Ann sent me photo confirmation they had arrived, but until things were clear she didn't trust sending them to the atelier in Munich to start work on the brooch idea.

Stranger Than Kindness opened on 5 June 2020. I spoke to Christina on Saturday 13 June, a week later, and

176

she said she missed the silence of the unopened gallery, wandering around knowing this wonderful secret hadn't been unleashed. It mirrored my thoughts about waiting to release an album. She told me she was relieved that the gum was in place in its cabinet. She emailed me: 'Yes, the gum is the object in the exhibition that I'm most concerned about… and I normally handle works that are worth tens of thousands of pounds. I'm not sure why I feel this way. Maybe because of its story! It's unique, powerful and fragile at the same time. It is this small thing that holds a great story, and in that way it reflects the idea of the exhibition: how things can carry a story and a meaning much larger than the thing itself.'

Rachel sent me a link to a story concerning Alex Ferguson (apparently he's a football coach) and the last piece of gum he chewed, which sold for almost £400,000. I forwarded the link to Christina then called suggesting we may need to renegotiate the value of Nina's gum. She agreed and then confessed there wasn't that amount available in the policy, but that we should reassess its replacement value. She said it raised a concern she had had for some time and she couldn't deal with the anxiety that having the gum on tour was causing her. She again suggested that we may need to make a replica to go on tour. She told me they had researched how to preserve the gum in the cabinet. The problem was it is made of a material of which there is not really a precedent for conservation. Gum doesn't feature in museums. At all. They decided to test the LED light temperature to check it wouldn't cause the gum to dry out or the colour to fade. They decided that they would apply the same system used on Hans Christian Andersen's manuscripts to regulate the humidity of the cabinet.

She again told me how relieved she was it was locked safely in its cabinet. She told me there was no way she was taking the original gum on tour with the exhibition. She told me that she walks through the exhibition and regularly checks the gum is still there and is always filled with the same twisting in her stomach when she sees it or thinks about it.

I told her I always have this twisting feeling in my stomach when I know a piece of music I am working on has potential. That uneasy shift of emotion and the unknown. When a piece of music or a fragment of sound is unfamiliar then it deserves a second chance. No matter how big or small. There has to be a point at some stage of the process where the idea and my emotions for it are linked. That I will fight for its existence until someone tells me to stop. Or it makes it through the gate. I find it hard to let an idea go. Otherwise it feels as if I've failed it.

Maybe the best thing is that a heist is perpetrated and the last image is like that fifteen-minute diamond heist scene from *Rififi* filmed on CCTV in the Royal Danish Library. Seeing a balaclava-clad face with eyes glowing like mine when I took it. Landing in some auction house, whisked into the deep web. In time it might be in the foundations of a gum pyramid-shaped house of worship to Nina Simone, with worshippers clad in her outfit from that concert in 1999, made up like Egyptian deities. I must leave the 3D scan on a chip under the marble plinth for reference.

I no longer had control over the gum. From the moment it had left my drawer, in fact, it was taking the reins. It was creating its own life, like an album, or film, or painting once it has been let go. That word 'idea', is this what it means? I became aware the story was much bigger than I had initially thought. It continued to ignite people's imagination in a profoundly beautiful way.

22 June 2020

Hello, Warren
This is Theodore (Jim's & Howe's friend). I hope you have managed during the last three months with the lockdown & virus.
Apologies for popping up again, I just wanted to send you these links that have some pictures of a memorial 'sculpture'

for Arleta, unveiled yesterday in Athens.

Unfortunately I cannot find any links in English.

A lot of people deem this 'sculpture' as 'garish' and underwhelming. As it is in Exarcheia Square, I hope it does not get vandalised or sprayed with graffiti.

Good luck with your endeavors – hopefully we will meet again someday in London.

Have a good summer.

Kind Regards

Theodore

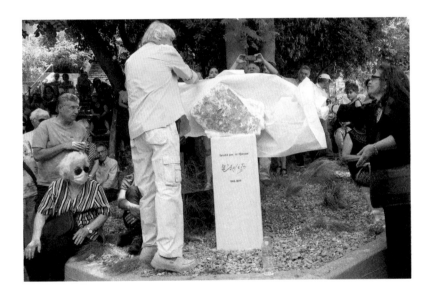

Somehow she continues to let me know what's happening. Others have become the caretakers of the love I hold for her. The sculpture was in the same colour stone as the marble she offered me in 1999, which I still carry in my washbag, and weirdly resembled very much the piece of gum lying on its side. Or a kidney.

31.

2 July 2020

To all you wonderful folk at Invada, I am contacting
you with regards to the artist Warren Ellis and would be so
grateful if you could connect me with him because I would like
to enquire whether he would be able to interview live on stage
the singer, actress and producer Lisa Simone, whose mother,
Nina Simone, he and Nick Cave were huge fans of. Lisa is
performing a unique one-off concert on 3 April 2021 with me in
London. The first part of the concert will be 'in conversation'.
Approaching her 60th year it is unlikely that Lisa will do
another onstage interview in the same candid way she wishes to
approach this one. Thank you for your time and I look forward
to hearing from you.
Jack

I reached out to Jack. I told him about this project and
that I would like to give Lisa a cast of the gum. He told me she
had enjoyed the discussion in *20,000 Days on Earth* between
Nick and myself about her mother and loved the conversation
about the gum and she thought I might be perfect for the
evening as a moderator.

4 July 2020

Ann Demeulemeester texted me to say she had set up
a plan to realise a jewel. She told me that she wanted to work
with Klaus Lohmeyer in Munich, the same jeweller who made
the pigeon-foot ring for her and with whom she'd been working
since 2005 for her own jewellery collections. She reassured
me that he was a skilled and sensitive craftsman. Every little
detail of the rough cast would be safe and put into focus by
the way he works on the silver.

She said she decided against a brooch. If it is worn on a jacket then it would be away from your body when you removed the jacket. Her instinct told her it needed to be precious and close to the body. She decided it would be better as a ring or a pendant. She wanted a ring because 'the circle is a magic shape that was like a spell always present in her work and life. A ring could create a nimbus around Nina's energy. The gum would be close to the skin, and the ring had also the ability to rotate the gum to show either face.' She also wanted it to be possible to wear it as a pendant for a chain. Ann called me and said she wanted to introduce me to the piece. She said she had it in her hand as she spoke to me. As we spoke she emailed me the images so she could gauge my reactions.

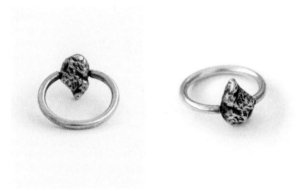

I was blown away when she sent the images of the transformation. I understood why she needed the raw casts; this ring felt ancient and timeless. She wanted to hand-deliver it on the train, but Covid-19 prevented travel. She was concerned about mailing it. We started texting again the Sunday after I received the images. I told her how beautiful I found her creation.

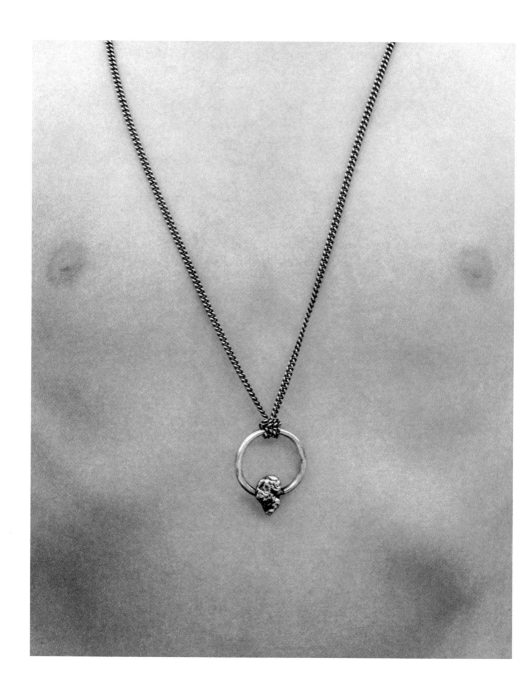

I mentioned an idea to make a sculpture of Nina Simone's gum. The serendipity of the image of the statue to Arleta must have jolted this idea. It seemed the perfect way to make it available for people to gather around it beyond the exhibition. A Welcome Nugget. I didn't want to manufacture the cast in such a way to make it readily available, a commodity; it felt like that would be diluting the whole story. But I want people to be able to be in the presence of the gum. An idea took shape. Ann wanted to collaborate. Ann told me her first love had always been sculpture and only later she had decided to move into fashion. I said I found it beautiful that maybe the gum might allow her to realise that first love. The idea of a sculpture, so people can travel to see it, gather around it, arrange to meet in its presence. 'Let's meet at Nina Simone's Gum.' We started imagining places for the sculpture. I started to envisage seven statues for seven continents. I started thinking of an unveiling in Antarctica, the sculpture covered in albatross shit and with penguins climbing all over it. Ann said there was a foundry in Flanders she had always wanted to visit and thought they might be the place to make the sculpture.

I asked Ann what it was about the gum that made her connect with it. She told me it made her stomach tie itself in knots. She said it had the same effect as a piece of music or art that moved her beyond understanding. This unique transmission of creative energy. A way to communicate, to bring Nina's energy further into the world. She said she thought of the poem 'Howl' by Allen Ginsberg. I asked which part of 'Howl'. She replied, 'Holy! Holy! Holy! Holy! Holy! Holy! Holy! Holy! Holy! Holy! Holy! Holy! Holy! Holy! Holy!'

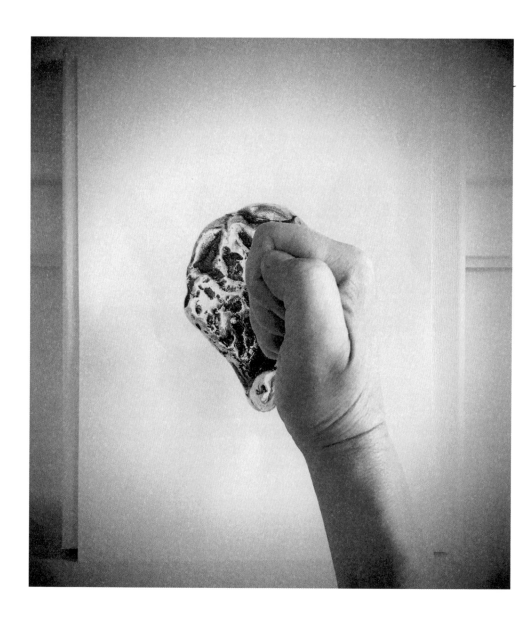

32.

We began discussing the size of the sculpture.
The larger it was the more diluting the effect. I had initially
thought of a seated black panther on its hind legs. She
suggested heart-size after reading a draft of the text. It made
sense: the size of a human heart. She sent me a photo of the
ring she had designed around the neck of Raven, her grand-
child. The image reminded me of a house key on a piece
of cord.
 We discussed the idea of having the sculpture incor-
porated into some seating arrangement. We settled on the size
of an adult heart. The same size and shape as a clenched fist.
 Potential locations for the sculpture:

– Uluru
– Mexico City
– Ivry-sur-Seine
– Antarctica
– a rainforest in Borneo
– Kinshasa
– The West Bank
– Sahara Desert
– The Dead Sea
– the Silfra fissure in Thingvellir National Park
 in Iceland
– near the Sphinx in Egypt
– Jordan

We need Nina Simone more than ever: her voice,
her strength and resolve. Her defiance, courage, fearlessness.
Imagine a Nina Simone heart-sized gum in the Statue of
Liberty on Ellis Island.
 17 July, Ann visited a Flemish atelier to enquire
about making the sculpture of the gum. She took the ring she
had created with the cast and the 3D scans of the gum I had

emailed. She was shown around the atelier and watched the process of casting.

The owner's grandfather made sculptures for Cimetière du Père Lachaise in Paris. I love that place. The tomb of Jim Morrison is there and the surrounding trees around the tomb are covered in chewing gum people have stuck while visiting his headstone. There are messages and initials scratched in the gum, written in ballpoint pen, stuck as high as the hand could reach while perched on another's shoulders. They clean the trees periodically. They put a Perspex wall around the tomb of Oscar Wilde because the lipstick left by people kissing the headstone was eating away the stone. But devotion is above the law, and people continue to kiss the Perspex screen and stick gum on the tree.

Ann contacted me after the visit to the atelier. She said she had a good feeling from the owner. She felt it was the right place to trust with the project. He wanted to make the cast because he loved the story of the gum but admitted he wasn't aware who Nina Simone was. My son's friend Leon heard I was sitting in my shed in the backyard trying to write a book. He heard it was about a piece of gum and asked me if this was true. I explained the premise of the book. He wasn't aware who Nina Simone was either but he thought the idea of a book about a piece of gum on a marble plinth that I had taken care of for twenty years was '*délirant*' and wanted to read it.

33.

Our actions have repercussions whether immediate or
years later. In our lifetime and beyond our years. Tiny depth
charges set off miles below the surface of the sea. Watching the
ripples form, then expand and vibrate, connecting continents.
Actions waiting for an answer in the future. Ideas waiting
for people to attach to. Waiting to be heard. To remind us.
To connect us. To make us imagine. Dream. With the closure of
ideas we make them infinite. A circle. A ring. Eternal.

I wrote a five-word email to my older brother Steven,
16 August 2020, asking him a question: 'Do you remember
the clowns?'

He replied, 19 August 2020: 'G'day, mate, hope you're
all well. 100%. I remember clowns. I have given this some
thought over the years.'

I called my brother Steven on the landline telephone,
29 August 2020. We hadn't spoken about this in over forty
years. Historically we have shared maybe three emails. Spoken
maybe a dozen times on the phone in four decades. To say we
are estranged wouldn't even come close. He answered the phone.
I could see my brother as a little boy of 7 when he spoke.
Hear the wonder and excitement in his voice.

He relayed the story of the clowns and described the
moment to me exactly as I recalled. I would complete the
sentences he started in unison with him. He said, 'I can see
you now, clearly in my mind, you're 5 years old, bathed in light.'
He wondered why they made no sound. He asked if I remem-
bered the bottlebrush hanging over the fence they were scaling.
He said he never forgot the light. He remembered we searched
for evidence in the morning and found imprints of tyres on the
lawn. He 'wondered for the longest time why it wasn't front-page
news in *The Ballarat Courier*. Do you remember how quickly
and high they climbed in the trees? That was unreal, mate.'

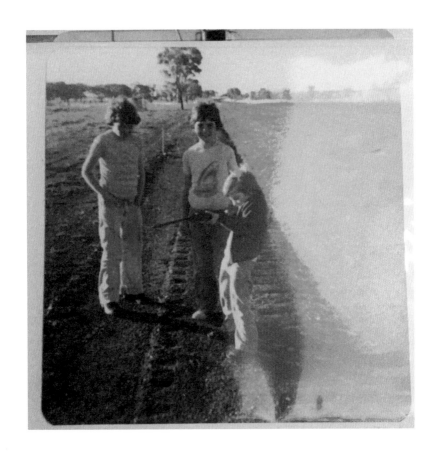

34.

1 November 2017 – All Souls' Day

I was in Vienna on tour with the Bad Seeds for the
Skeleton Tree tour and I decided it was finally time to go
to see Beethoven's grave, after soundcheck, before the concert.
I hadn't seen him since the eighties. I sensed I needed to go
to him. I took a taxi to Zentralfriedhof cemetery, Beethoven's
final resting place. He actually had three burials.

I pulled up to the gates, stepped from the car, and
bought some simple flowers bound with string and pine cones
from a caravan near the entrance. It just so happened that
it was the Day of the Dead, so the cemetery was full of people,
families. The sun had set and the sky was clear. There were
candles and fresh flowers everywhere and visitors all over the
grounds, walking around, having picnics at their relatives'
tombstones; laughter, joy.

I started walking through the cemetery with my GPS,
trying to work out where Beethoven was buried. Grave 29 in
group 32A. I quickly got lost. Which is typical of me. A woman
in her twenties came up to me and smiled, 'Can I help you?'

I must have looked as lost as I was.

'I'm looking for Beethoven's grave,' I said.

She smiled. 'I'm going there as well. Do you want to go
together? I know where it is.'

It struck me that she took on the task of leading
this long-bearded, middle-aged man in a suit and large dark
corrective-lens glasses through a darkening cemetery quite
casually. Almost like she was expecting me. I don't know.
I just wanted to see the grave, and lay the flowers. I put my
iPhone in my pocket and followed her lead.

We walked around the cemetery for a bit, then
we turned a corner and in plain view was a towering obelisk
in a cul-de-sac, with 'Beethoven' carved in large gothic font,
surrounded by flickering candles and flowers. As soon as I

189

saw it the atmosphere changed and the sky glowed with candle-light. I felt the lighted sky fall on me, drowning in candlelight. I stopped, frozen, and burst into tears. I fell to my knees, sobbing uncontrollably, my glasses fogging up. Pinned to the earth. I could feel a hand on my shoulder and I heard a voice.

'Can I help you?'

She bent down and took the flowers from my hand and helped me from my knees. She led me to the obelisk. Together we placed my flowers amongst the flickering candles and flowers. She stood silently by me. I stared at the name on the monument. I searched for the words. My body hummed. The only words that came into my head. 'Thank you.'

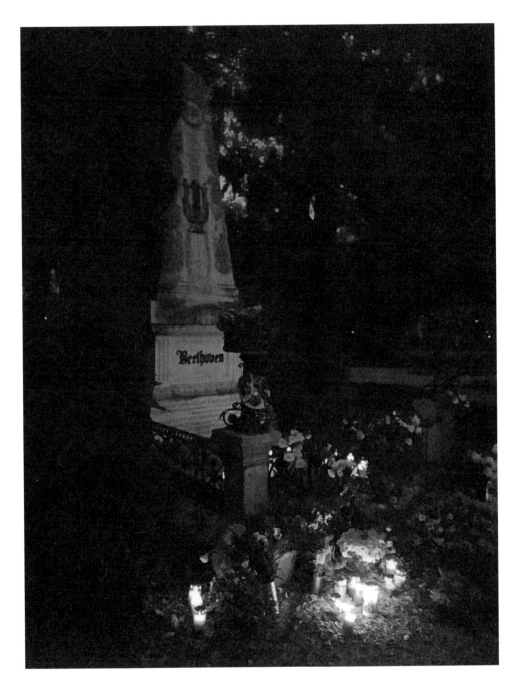

Afterword

Since writing my book, the story continues to develop in unexpected ways. I wrote that the book felt like the opening credits, and this continues to be correct. Some of its narrative seems predictable, but most seems fired in the furnaces of serendipity, awe and the wellspring of the imagination. The story, like a song or a poem, is reconfigured, repurposed and reimagined by whomever reads it.

The day I handed the final draft of *Nina Simone's Gum* to Faber, I was cleaning out a forgotten cupboard in my mother-in-law's apartment in Paris and came upon a suitcase. A chocolate brown, Samsonite, faux-crocodile-skin number that I had used in the nineties. It struck me as very small, not much larger than my briefcase, and I wondered what I must have carried in it. I remember at that time I had a deep-purple suit with velour lapels. I had walked into a thrift store before leaving Australia with Dirty Three in 1995, tried it on, then walked out leaving my clothes behind in the changing room. That became my stage costume for the next few years.

Inside I found:

- My old phone book
- Bank statements
- A script from Oren Moverman, dated 1996, for *The Hiding Place*
- Faded faxes
- A porcelain doll's head
- A script for *Praise*, directed by John Curran, the first movie I scored with Dirty Three
- Gold membership to Ansett frequent flyer club
- A metro ticket for the Paris underground
- A manilla folder filled with business cards and handwritten messages from people about stuff
- Letters from Mick Geyer
- Cassettes from Mick Geyer

- Postcards, letters and mix tapes from David McComb
- Laminates on lanyards for the Meltdown Festival
- Some X-rays of my hands and knee, with fractures from a car accident in Chicago in 1997
- Tracklisting for *Ocean Songs* album by Dirty Three
- A dried-up piece of lemon
- An empty folder with 'RECEPITS' written on it
- The original ticket for the Nina Simone concert at the heart of my book

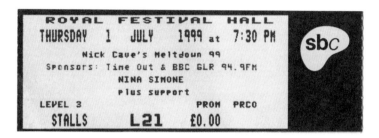

Unbelievably, the ticket was deep purple with a white rectangle for the printed information needed for the concert, which was the same layout as the cover of the hardback of my book, designed by Pete Adlington from Faber with no prior knowledge of the ticket.

I sent Dan Papps a photo of the ticket. I took it as a sign from Mick, Dave, Oren and even the great Dr Simone herself that it was time to let it go. Or as Mick Geyer would say, 'Let her rip, kid.'

When the book was printed, Nick called me to say it was in fact four of his upper vertebrae that were fractured in Iceland, not the lower. I had corrected this but sent an old edit. I think this happened several times when trying to come to terms with Word. TextEdit always struck me as idiot-proof and needed no manual for operation

I had also meant to include the fact that when I was given the tape of Arleta, it came with the caveat that she had made two albums and then committed suicide. So, this story attached itself to my listening. After the concert in Athens in

1995, when the audience sang along to our version of Arleta's song, I was approached by the promoter, who asked how we knew 'Mia Fora Thymamai'. I told him the story of the tape and said how tragic it was that Arleta was dead. He looked at me and said, 'But she is alive and lives three blocks from here. She still plays concerts from time to time. Would you like to meet her one day?' And so I did. She suddenly seemed Lazarus-like.

I don't think that new knowledge would have changed how I felt about the music if I'd known when I was given the tape, but it did add a certain tragedy to the whole package. It's curious how songs, films, books, people, attach themselves to us depending on how we are feeling at that particular point in time. How revisiting them can be a totally different experience years later, in hindsight, and how the good stuff always stays good.

In August 2021, four years after Arleta's actual death, I went to visit her statue in Athens. I had great difficulties locating it as it wasn't Googleable or in any tourist brochure. I went into a bookshop in a square in the area I thought it must have been, based on the article I'd read, and the attendant found the GPS location and pointed me in the right direction. There it was. On the corner where two streets intersected, surrounded by rubbish and unwanted building materials. I smiled when I saw it. I imagine Arleta would have giggled herself. I took a photo of myself sitting next to the statue wearing a perspiration-soaked, tourist souvenir baseball cap with ATHENS stitched on it, the 40-degree sun beating down on me.

Everything in the book is true; nothing was invented for the sake of the narrative. I was asked this question a lot while promoting the book upon its release. I found the promotion of it much more satisfying than an album. Interviews about musical projects mostly seem to do them a disservice. The listener often has a better take on them than the creators. And who are we to say what was intended once they have taken on a new life in the greater public's hearts.

I went to visit my friend James Thierrée in Paris to discuss a theatre project and told him about my book. He smiled and said, 'Do you want to see my most precious object?' He came back with a worn, woven cane wastepaper basket. He explained to me that when his grandfather, Charlie Chaplin, passed on, he was asked if he wanted anything from his personal belongings. He had already been given his violin, which he donated to a museum in Switzerland. He said all he wanted was his wastepaper bin. He loved the idea that it had held all the ideas Chaplin was unable to make work. He uses it to throw his own ideas in, and dreams of maybe one day pulling out some his grandfather couldn't realise.

I had anxieties about stepping into writing – such a new unknown world – and was equally concerned about how it would land. These thoughts are a poison to creativity, and I wish I could listen to them less. They are just mirrors of your own insecurities and say more about you than anything else.

My father sent me a text: 'I read the entire book out loud. And loved every word. Now we are going to read it again in the same way.' I could hear his voice reading me stories as a child, reciting prayers in the hallway.

198

Andrew Dominik read my book and asked if I was going to mass produce the gum.

'Everyone will want it, Woz!'

I said I hadn't planned to, that it would dilute the story of the gum.

'Mate, I get it, but imagine if it became the new crucifix.'

Makes you think.

The discussion for the sculpture continued with Ann Demeulemeester, and finally, on 6 October 2021, it was placed in my hand by Ann. I was on tour with Nick for the UK and European Carnage Tour dates when the lockdowns lifted and touring had started to crawl slowly back to life. The sculpture is beautiful, heart-sized, and with a patina that rubs off, like the Everard t'Serclaes monument just off the main square in Brussels, where everyone touches its forearm for good luck. The foundry who made the gum sculpture made the t'Serclaes bronze. We decided it should be displayed the same way it lay on the towel, so the underside isn't visible. The side I had not seen for twenty years. We are working on locations, waiting for the right people to engage with the idea. It will happen though.

The Southbank people heard me talking about my book and my concerns about what to do with the actual gum on the BBC. It feels like it has been released in the world and I want people to see it, stand before it, commune with it. They reached out via a landline phone call to Faber to say they wanted to acquire it for their archives, with the towel, Tower Records bag and original ticket for the concert to be displayed with other artefacts from Dr Simone's performances in their possession. The providence of the towel was somehow overshadowed by the gum in my book. The Tower Records bag has attached itself to the relic's journey.

I gave a silver copy of the gum to Faber for the care they took in presenting my story. I was happy to learn that it will eventually reside in their archives with the manuscripts

of Sylvia Plath and Ted Hughes, Samuel Beckett and W. H.
Auden. A beautiful thought.

I saw Christina Back from the Royal Danish Library at
the Royal Albert Hall on 7 October during the Carnage Tour.
She said to me, 'We need to talk about the gum.'
I said, 'Alright.'
The Stranger Than Kindness exhibition would be
touring for four or more years globally, and she said she
didn't want to take it. I asked why, and she replied solemnly,
'Because it's going to be the death of me, Warren!' I explained
that a copy wasn't the way forward; if it was to be displayed,
people had to see the real gum. It was Doctor Simone's Gum or
nothing. I asked where it was at present.
'It is in a specially constructed container that keeps it
at 20 degrees Celsius, in a safe in the Royal Danish Library.
It was the last piece of the exhibition to be installed before the
doors opened, and it was the last piece to be taken down when
we closed and packed all the exhibits away. I wanted to be
there when the glass panel was unscrewed and witness it go in
the container into the safe.'
I said we would have a think about it
Five days later, I received a text and a photo. The gum
was back in the Bonne Maman orange marmalade preserve
jar Hannah had placed it in, and it was sunk in a large box of
foam, 60cm by 90cm, contained in a thick cardboard protective
outer box.
'Here's the gum preparing to go on tour. I am ready
if you are.'
I replied, 'Fuck, yeah.'

14 February 2021

I was working on some music with Nick for a
documentary on snow leopards by Marie Amiguet and Vincent
Munier. Vincent is the most amazing wildlife photographer.

His father took him into the countryside when he was seven and showed him some deer grazing in a field from behind a wall of trees. He told Vincent to look. Vincent looked. He has photographed animals ever since. Vincent and Sylvain Tesson went to Tibet in 2018 to try to photograph a snow leopard. It is a film of savage beauty, great wonder and awe. While working on the film, I was moved by Vincent's work and passion for animals. It opened something in my heart. While in the studio, I received a text from an old mate, Lorinda Jane, who booked Dirty Three in the early days, the early 1990s to be precise. She asked me if I would put my face on a beard balm product that was palm oil free, and the proceeds would go towards protecting orangutans displaced by the palm oil plantations. I said, 'Of course', then asked her how I might be able to do something more substantial.

A few weeks later, Lorinda introduced me to Femke den Haas, a wildlife warrior living in Sumatra. Femke has campaigned tirelessly for the rights of animals for over twenty years. On a Zoom chat, she told me she needed a place to build a forever home for animals they rescued that couldn't be released back into the wild. Animals who had been abused, locked in tiny cages for years, beaten by people and left for dead. I was moved by the idea of taking responsibility for others' bad deeds. I decided to purchase and donate some land to her cause. We would build Ellis Park, a sanctuary for animals with special needs. I wanted it to be something I did privately, then discovered we had to fund and build the enclosures, a medical centre, food storage, education centre and feed the animals. Noah's Ark for the broken animals. So, I put the idea out into the world and watched it take flight. The sanctuary has become a beautiful communal idea with people rallying under and around it with love and care to help us realise the project.

At the time of writing, we have two residents housed, a veterinary hospital built, an education centre under construction and the food storage functional. We have been fully funded for construction. We are building a memorial

garden for people who want to remember loved ones who have passed away, marking the trees with their names. The aim is to eventually build a place where old, unwanted elephants from zoos can live out their lives with dignity by the river that borders the park. In my book, I had thought to put a gum sculpture in the statue of liberty on Ellis Island. Instead, we will build a large sculpture of the gum in Ellis Park for the armless monkeys and toothless bears to play on. I plan to take a boat trip to Sumatra for the unveiling. Down the line, I might just end up at the park, peeling bananas for the animals, get back on the gear and go out in a blaze of glory.

I met up with Australian director Justin Kurzel and producer Nick Batzias in Cannes and told them about the park. The next day Justin contacted me saying he wanted to make a documentary about it, the animals and the gum being installed. The work in progress is tentatively titled *Blaze of Glory*. I asked Nick Cave if, down the line, he wanted to come along and play with a local Sumatran orchestra for the animals only, on a hill overlooking the park, and he replied, 'Beautiful idea! Let's look at it when the Covid thing has passed.'

The park is very much like the premise of the book: that ideas need love and care to take flight. Ideas becoming

communal. The gum feels like the totem of goodwill and hope with its arms around the park and animals. Dr Simone surveying it all. Defending the downtrodden.

On 24 February 2022, a day that made no sense at all, I went with Nick to Nina Simone's birthplace in Tryon, thirty miles outside Asheville, North Carolina. It was the beginning of the North American Carnage Tour. I wore my best formal suit and favourite stage shoes. I placed a copy of the gum and my book on the windowsill overlooking the front porch. I figured she must have sat on the sill as a child. I hung the gum necklace that Ann Demeulemeester created from a nail hammered in the front door. I figured she opened that door. I could see the church she must have played organ in as a child. I sat under the magnolia tree beside the house where she must have played. I sensed a circle had been closed. Taking the gum back to Dr Simone.

While visiting her birthplace home, I received the layout for the paperback cover with the image of Ann's grandchild, Raven, wearing the gum pendant ring. I sent the layout to Ann to ask if it was OK to use it. She replied, 'We think it looks wonderful and serene and love the magic of it. It's Nina who organised all this.' When I returned to the hotel, I realised one of my shoes had split and was irreparable.

The more I talked about the book, the more I realised that people are ideas waiting to happen. Who and what we come into contact with, in our lives, can determine if our better selves evolve. Those moments of affirmation, when someone says, 'That thing you did there, it's great.' Those things that connect with something deep in you and ensure life will never be the same after witnessing them. I understood the little guy who witnessed the clowns in 1970 is the same person you see performing on stage. Filled with wonder and awe for the unexplainable. That person inside you that isn't the person you see looking in the mirror. The person who walks with you. To be on a stage is a privilege and a place of spiritual

channelling. A place where some sense of communion can occur between the audience, the performers and the other. When it is not, then that place would be better filled by someone who believes.

The world you create inside is mirrored outside. Release your ideas and let them land on others' ears. Enter their hearts. They need them to take flight. Keep the sacred and magical close, and don't listen to people who tell you it isn't true. Create your gods, and they will watch over you.

Warren Ellis
7 March 2022, Los Angeles

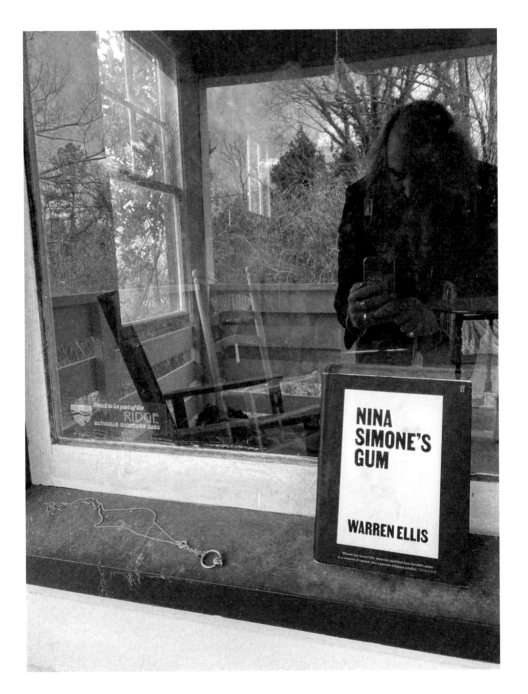

Acknowledgements

I would like to thank my family: Delphine, Roscoe and Jackson, for their love and support. My mother, father and brothers. Thanks to Nick Cave, Jim White and Mick Turner, who saw something I did not. The Bad Seeds. Rachel Willis who shepherded me throughout the entire process. Dan Papps for sticking with me through the thick and the thin. Oren Moverman for striking the match and pushing me on. Ann Demeulemeester. Magne-Håvard Brekke for his enthusiasm and illuminations. Christina Back for her advice and support. Stuart Bertolotti-Bailey for his beautiful layout. Faber. Emma Stoker. Laurie Anderson for her blessing to use Lou Reed's quote and to anyone who sat and listened as I ranted on about a piece of gum I stole last century.

Picture Credits